MW01076698

 TROPE PUBLISHING Co.

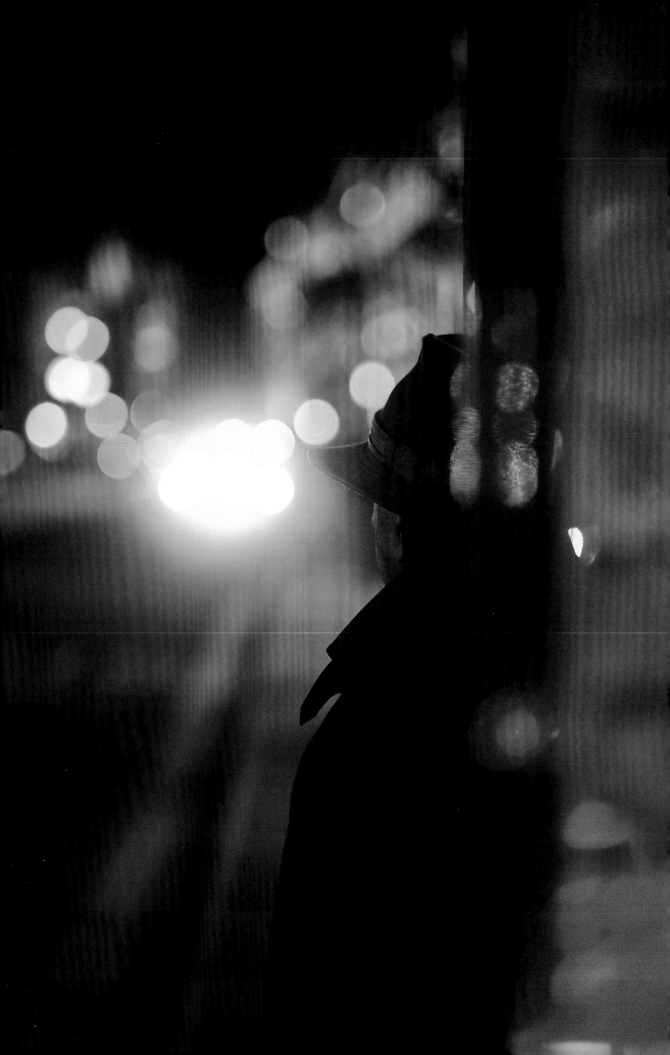

LONDON
AFTER DARK

BALWINDER BHATLA
AKA MR WHISPER

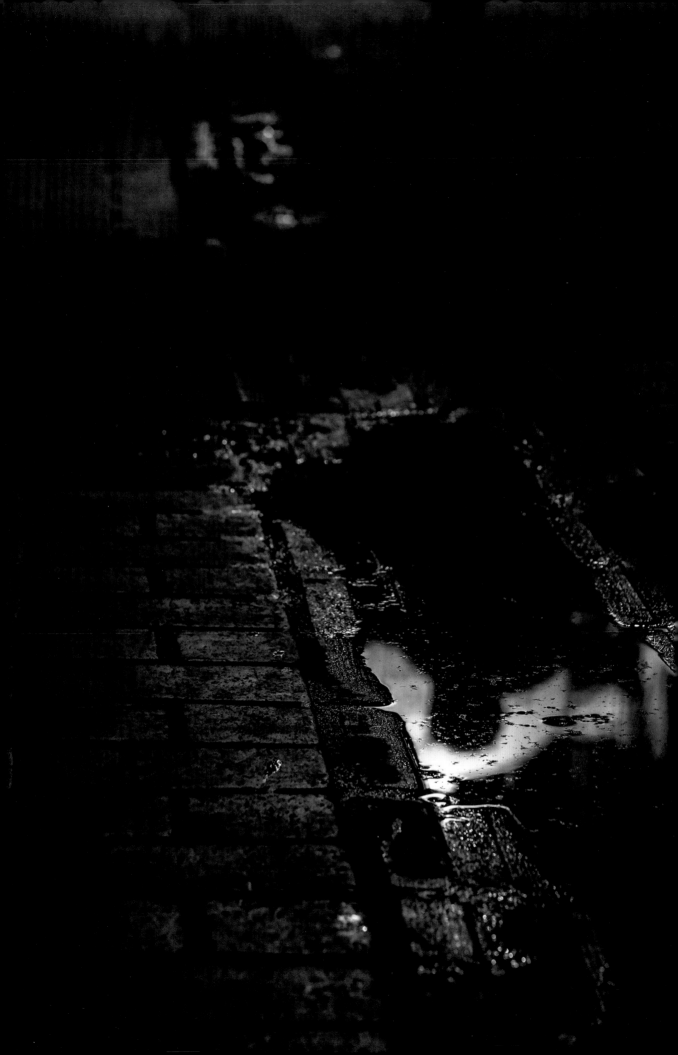

Dedicated to my late father, Pritam Singh Bhatla,
and brother, Tejinder Singh Bhatla, who always
inspired me to see the world differently.

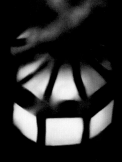

There's something magnetic about the streets of London at night. As the sun sets, the city undergoes a dramatic transformation. The bright lights of the theatres, cinemas and passing traffic illuminate the streets. The neon signs come to life, creating an almost cinematic atmosphere. It's like the city puts its makeup on. The mood's lightened. There's much more of an extroverted drive, and that really plays into the way I like to approach my storytelling. During those hours, you encounter the energy of unleashed Londoners, adventurous and carefree, chasing the night.

As a photographer, I am endlessly fascinated by the beauty and complexity of London's streets after dark, and it's this fascination that led me to create this book.

London After Dark is a collection of photographs made over almost a decade of countless evenings, step counts and shutter counts exploring London's iconic West End and beyond. Armed only with my camera and a keen eye for detail, I set out to capture the everyday moments of the city in a unique and compelling way, often using the visual language of London's iconic transport system to frame my protagonists.

Working in low light conditions can be challenging, but it also offers an opportunity to create images that are moody, atmospheric, and full of character. Whether it's the neon lights of Soho, the shadows and reflections of Piccadilly Circus, or the serene calm of the Thames at night, each photograph in this book tells its own story and captures a moment in time.

As a visual storyteller, I strive to create images that evoke a sense of emotion and connection with the viewer. Through my work, I hope to inspire others to see the world in a new light and appreciate the fleeting moments of beauty, intrigue, and raw emotion that are all too often overlooked in the hustle and bustle of daily life.

I am thrilled to share this collection of photographs with you and offer a glimpse into my nocturnal excursions. Whether you're a lover of photography, a fan of London, or simply someone who appreciates the beauty of everyday moments, I hope that this book resonates with you and leaves you with a newfound appreciation for your city after dark.

Enjoy the ride.
Mr Whisper

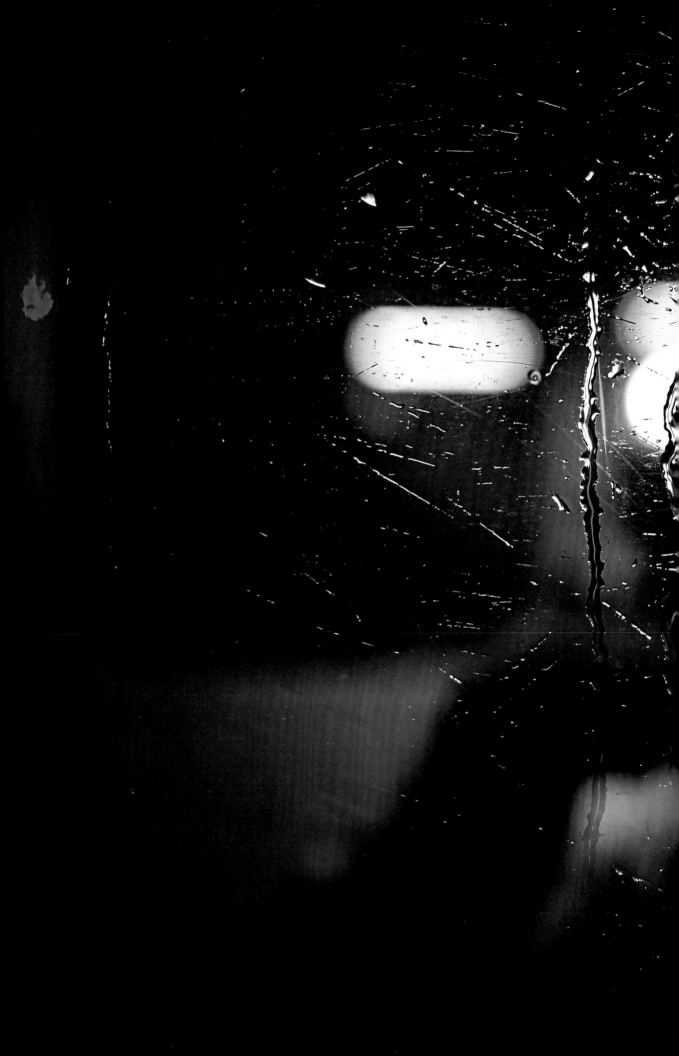

LONDON
AFTER DARK

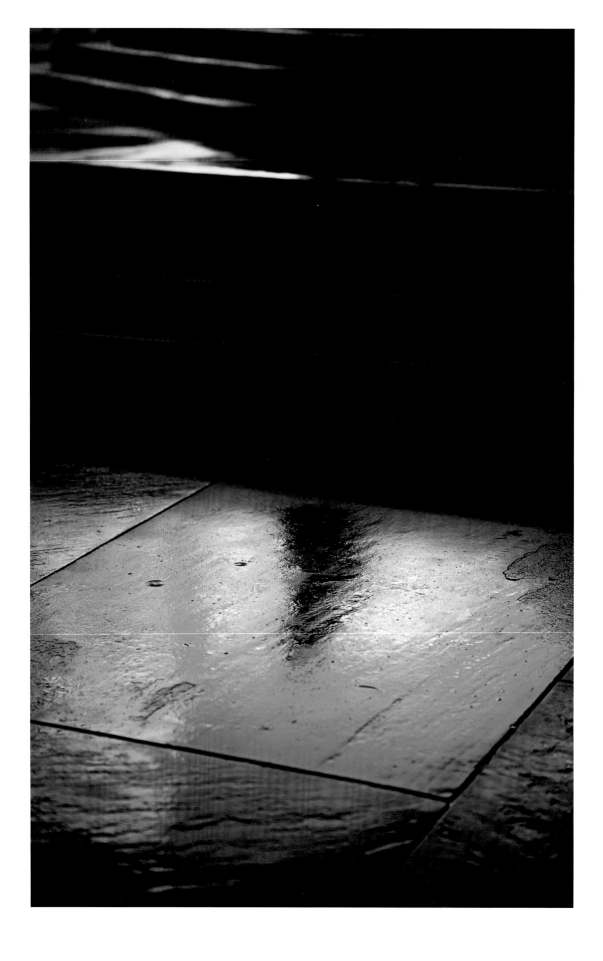

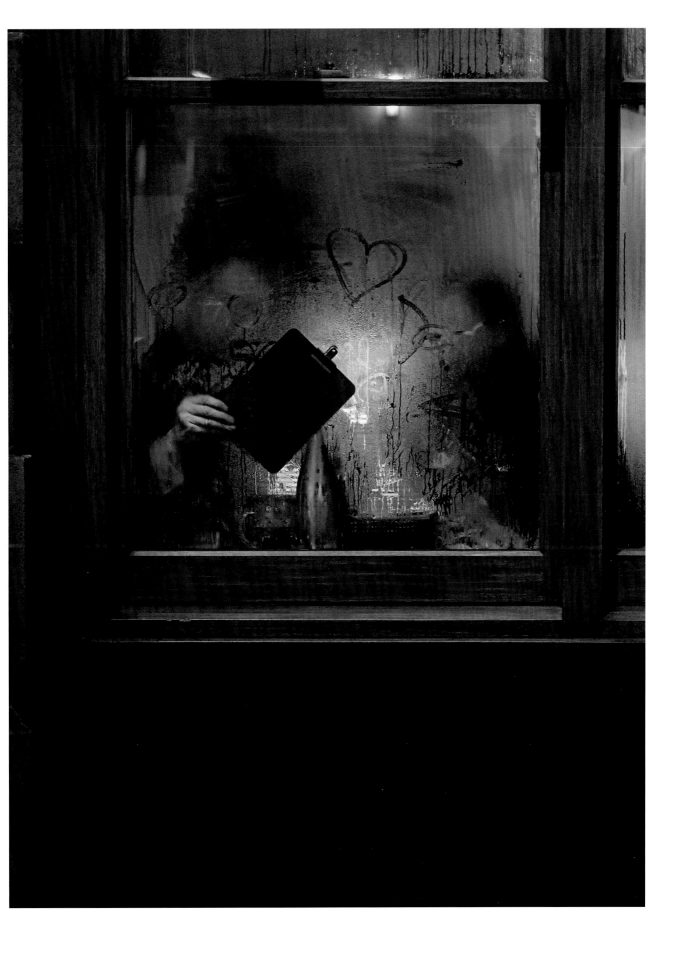

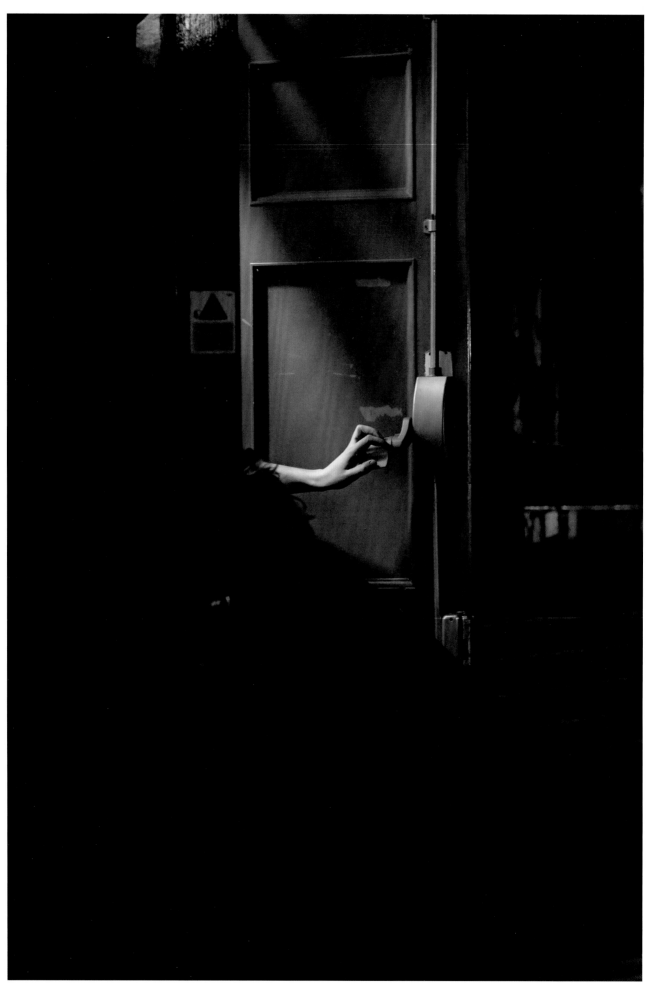

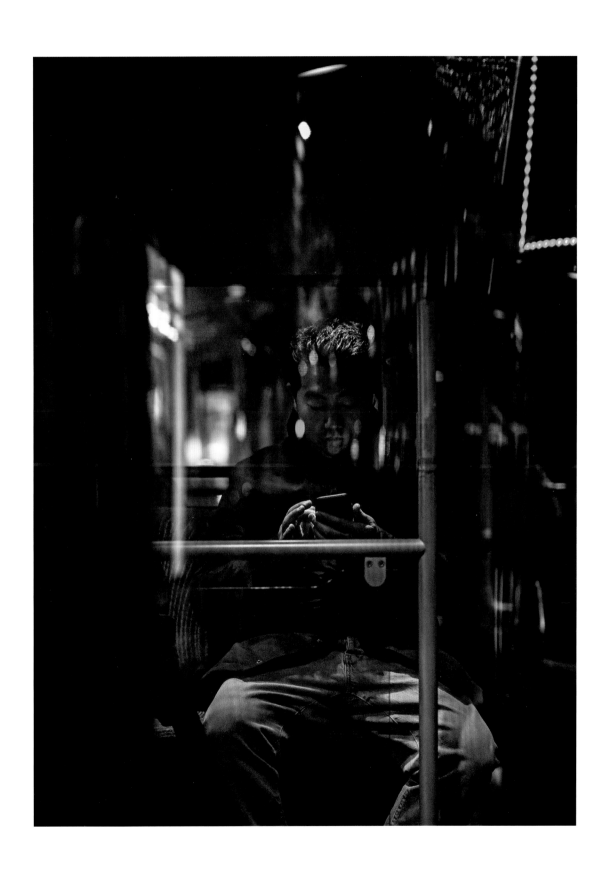

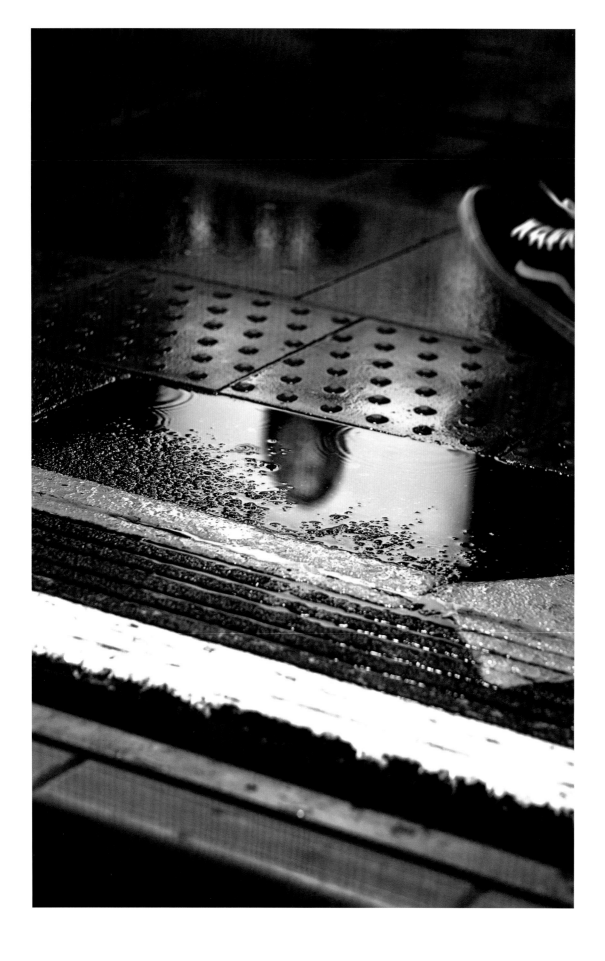

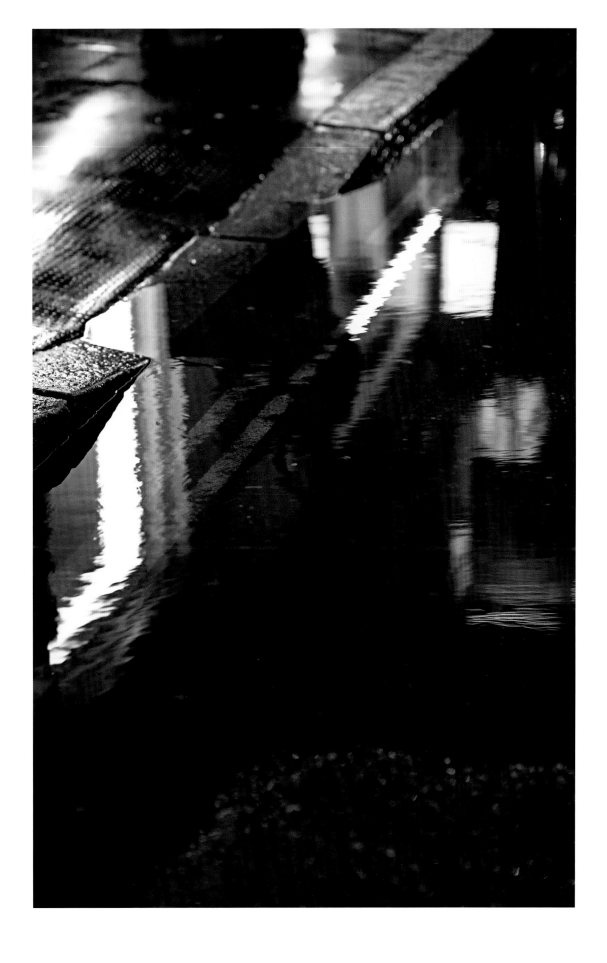

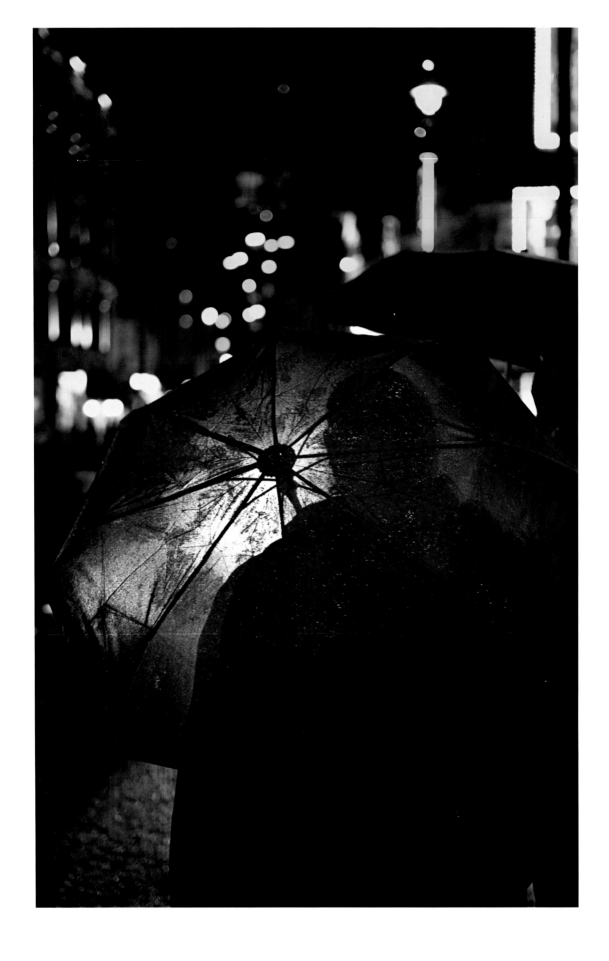

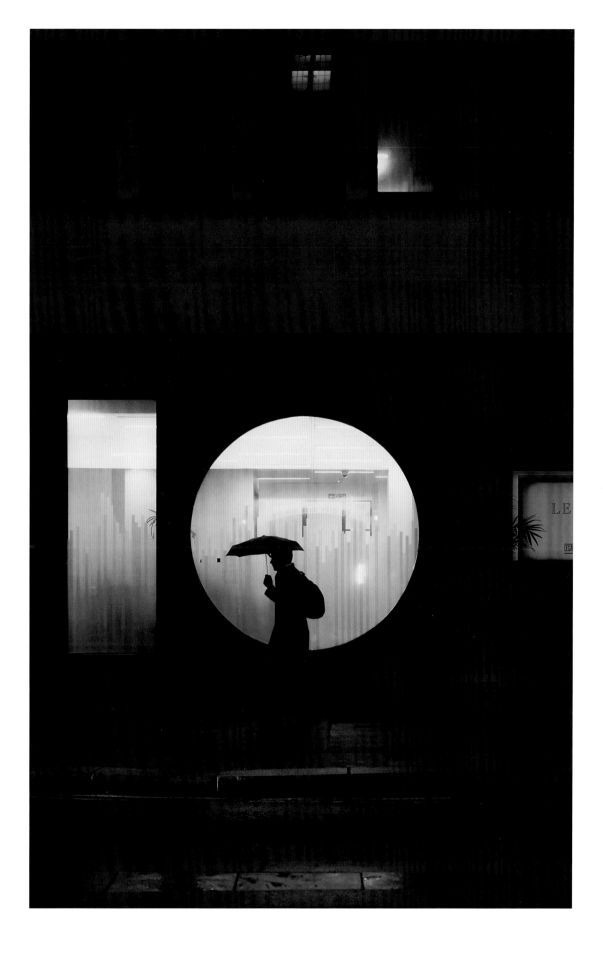

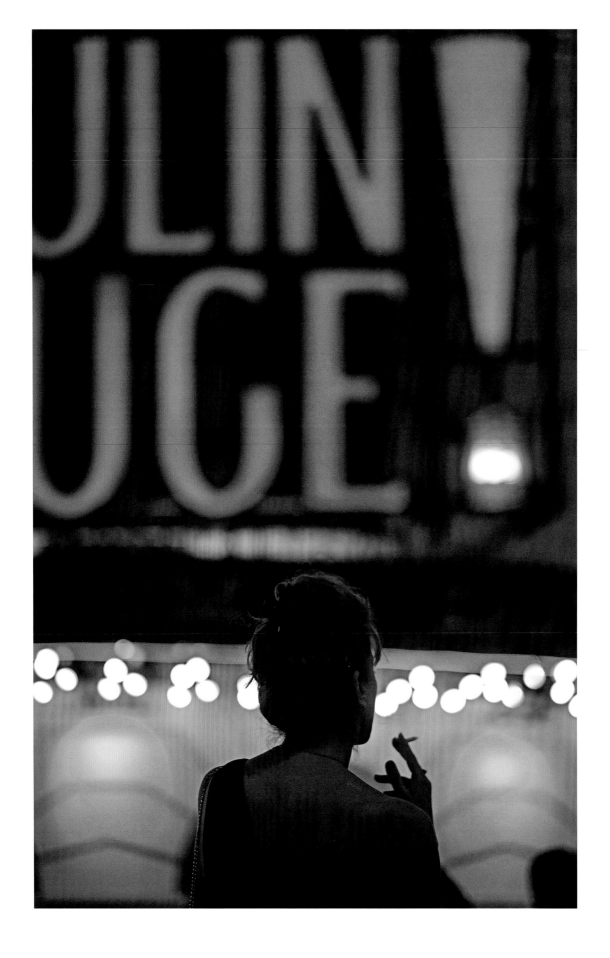

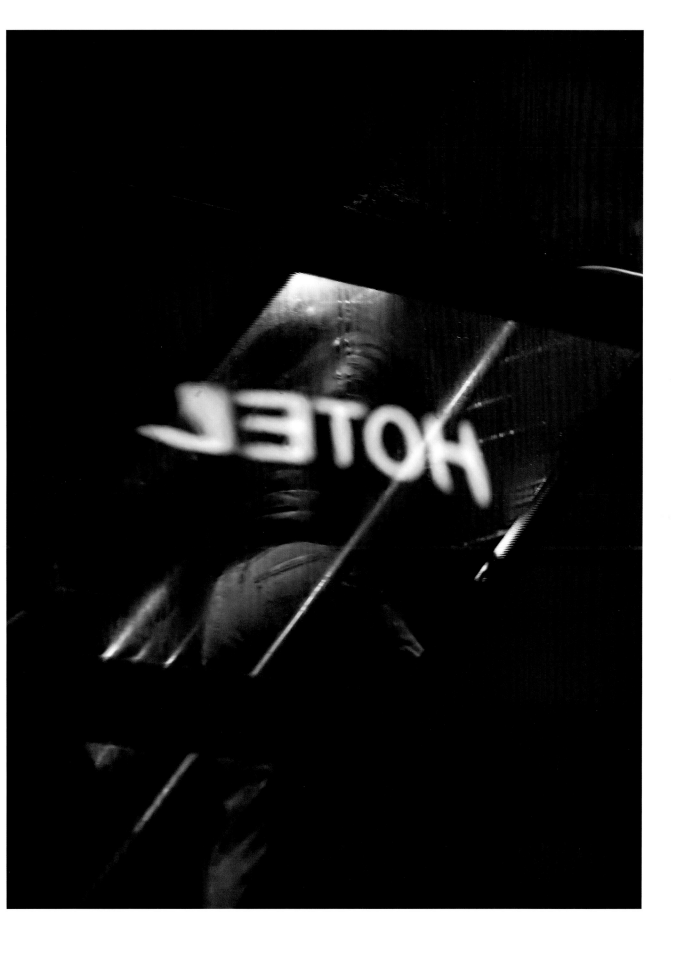

notes

TRAFALGAR SQUARE

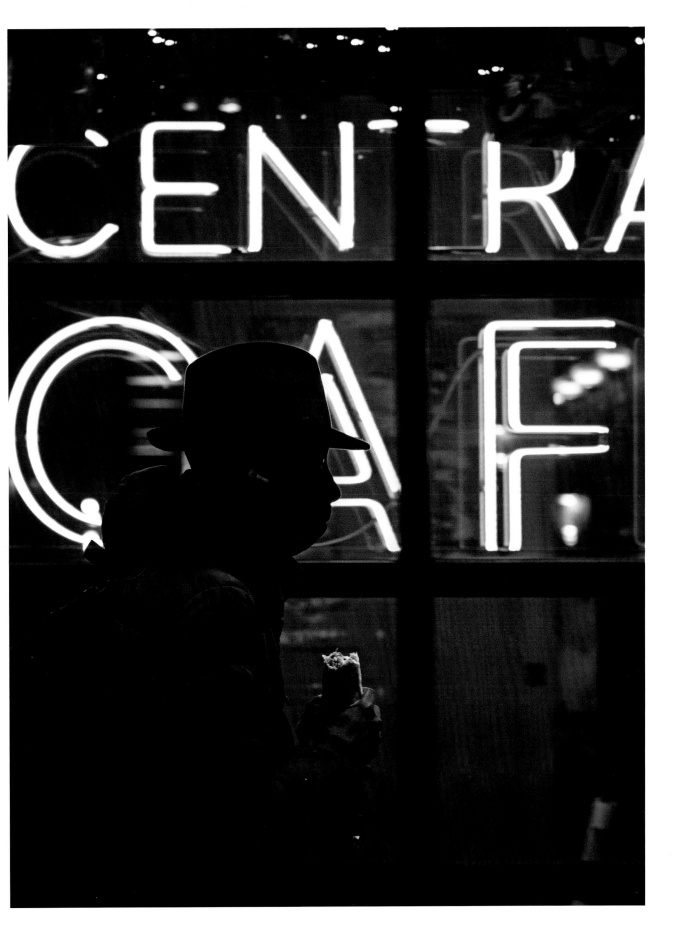

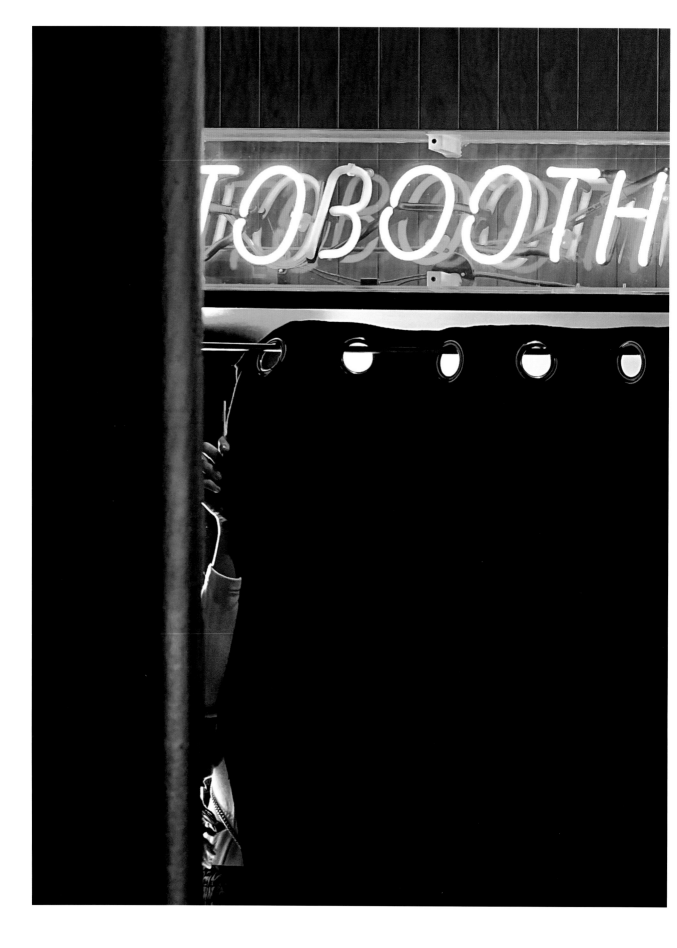

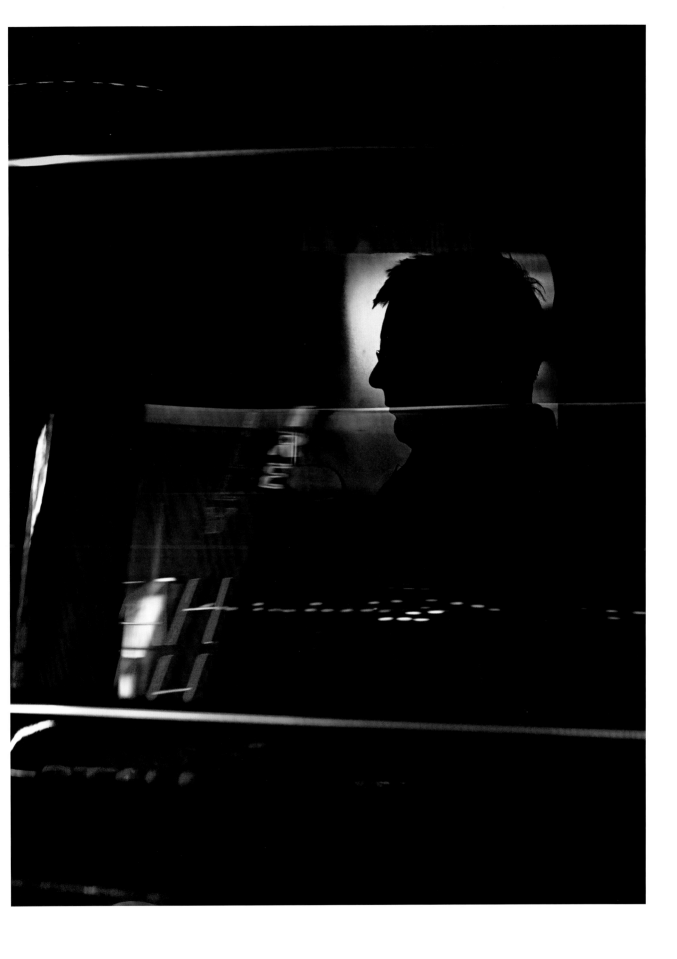

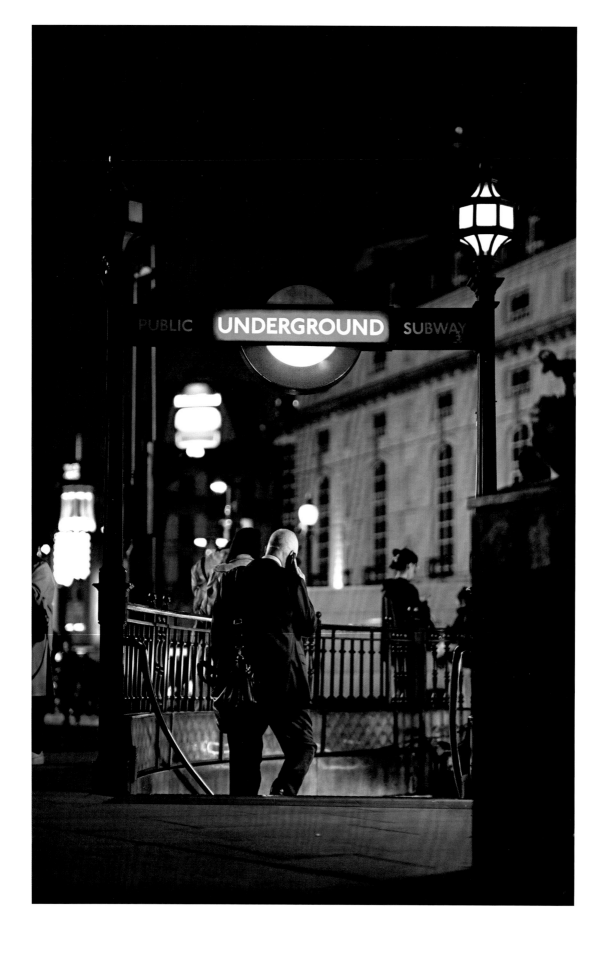

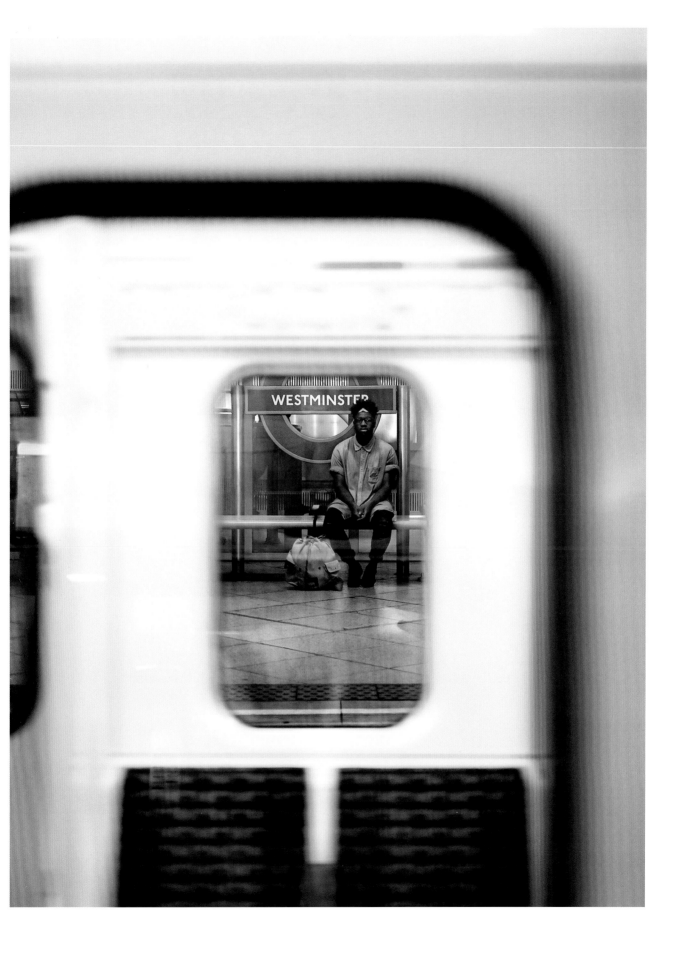

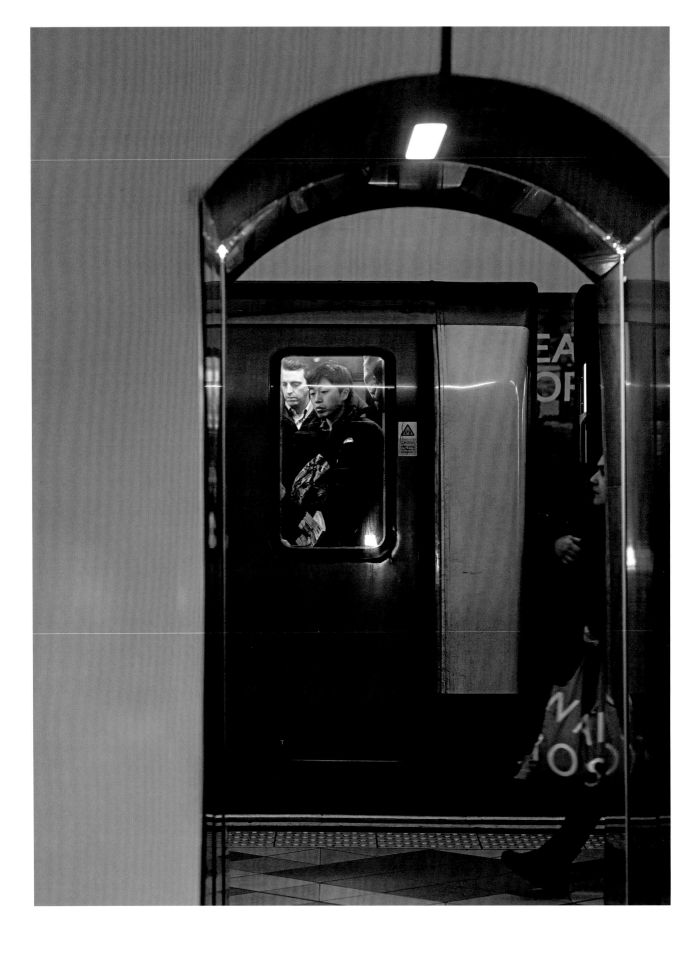

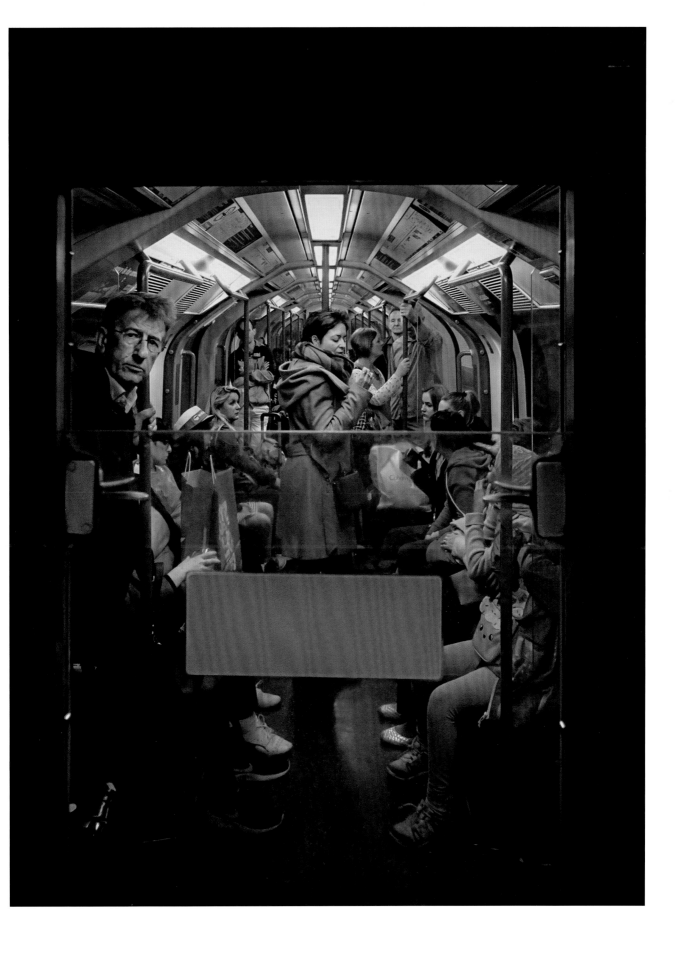

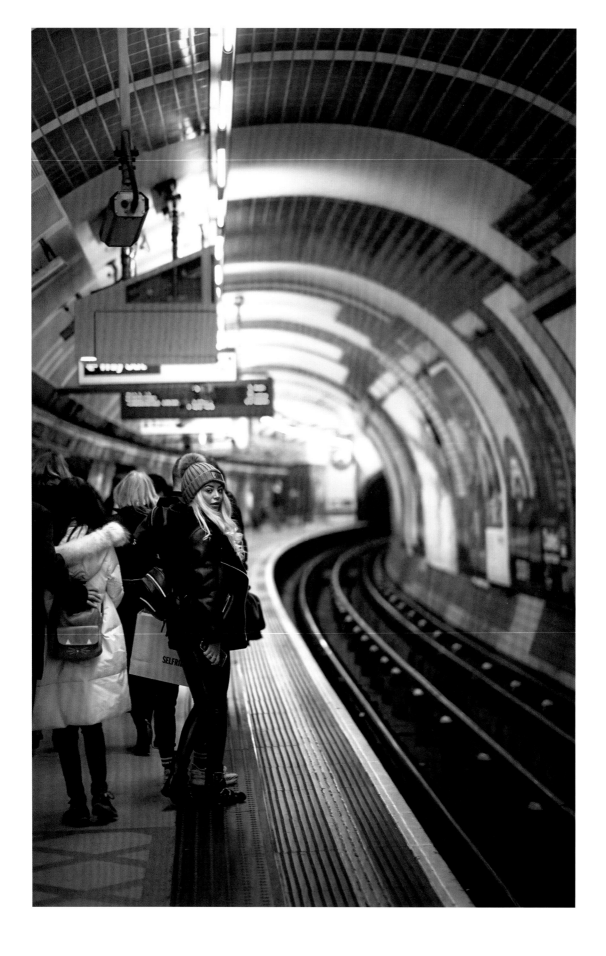

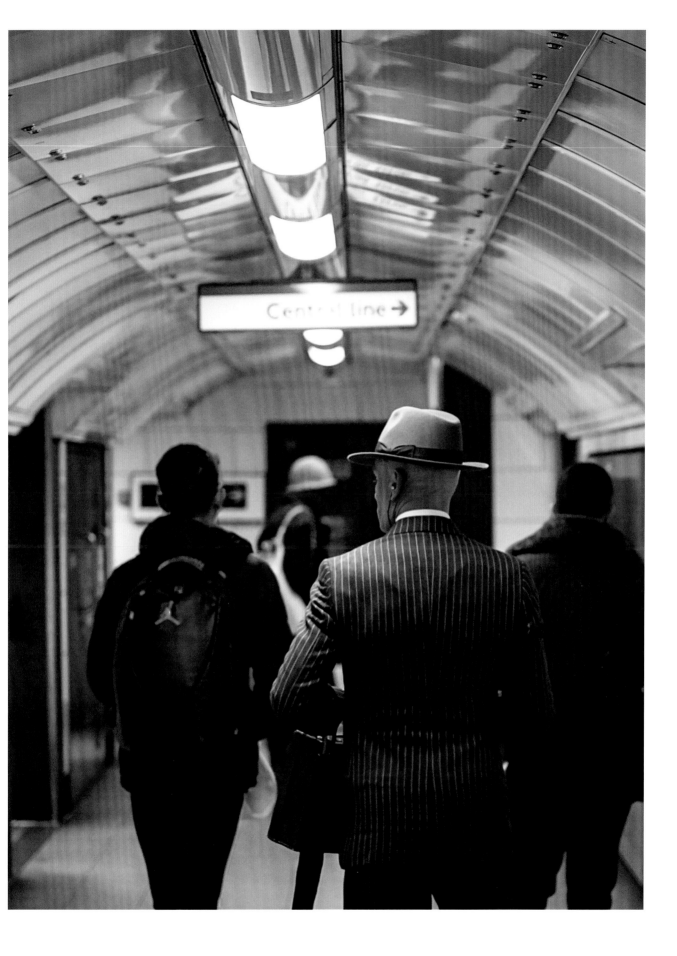

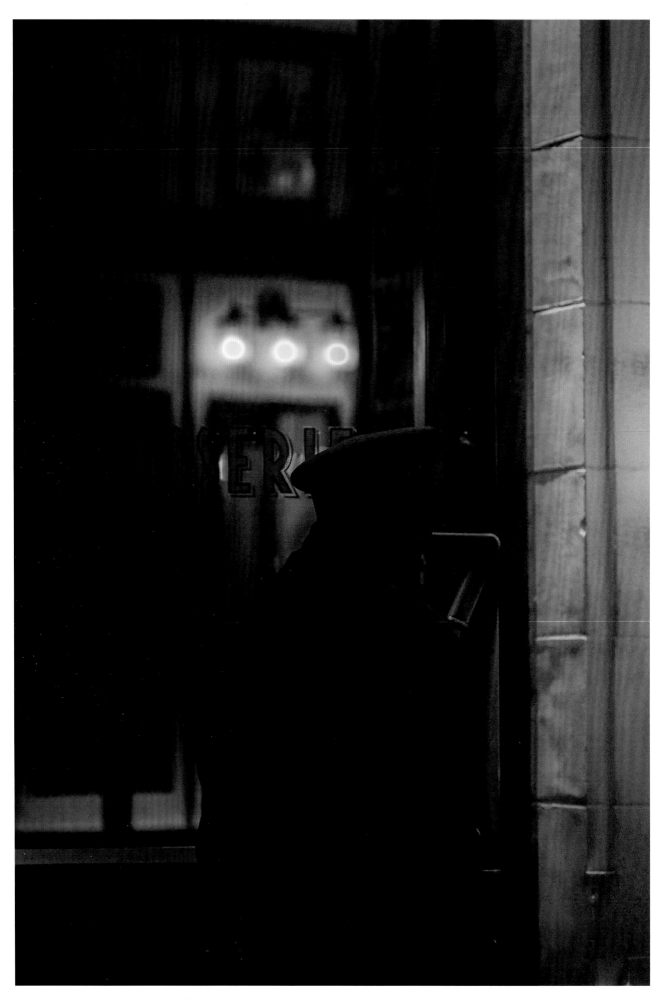

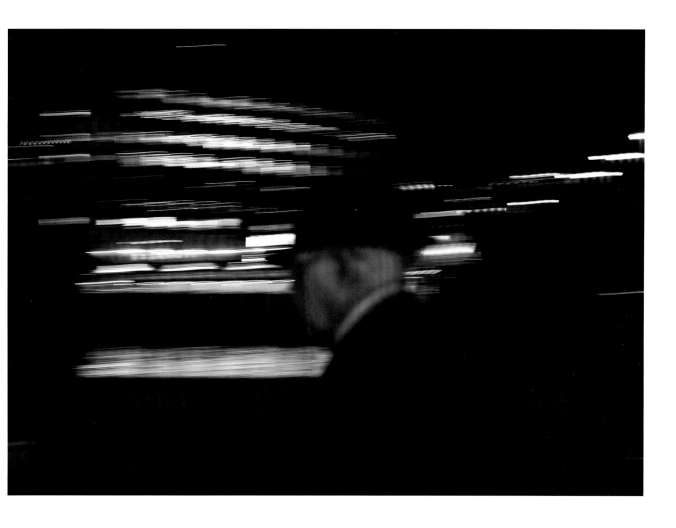

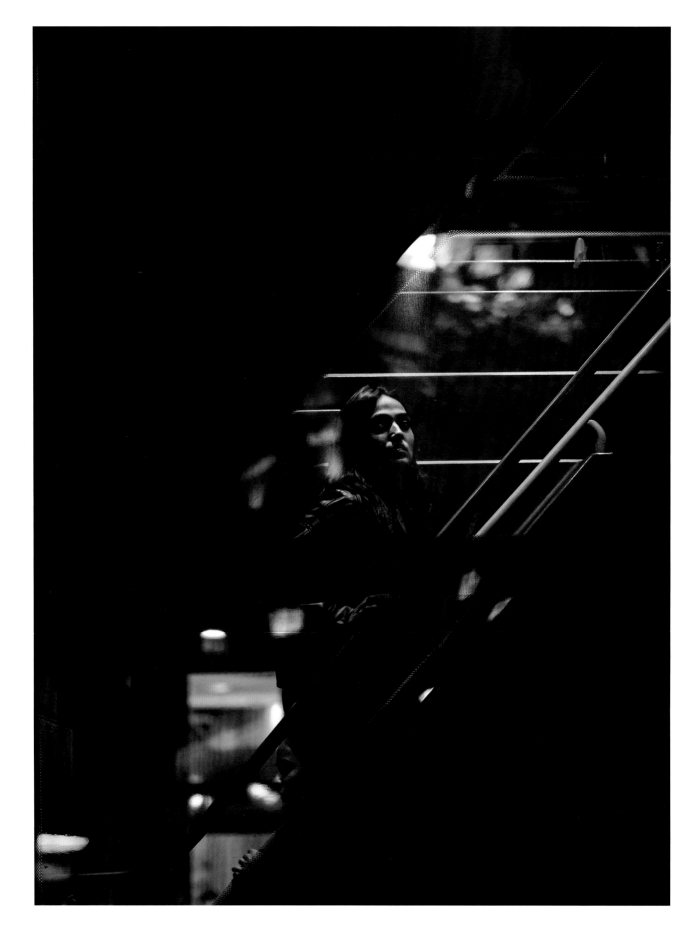

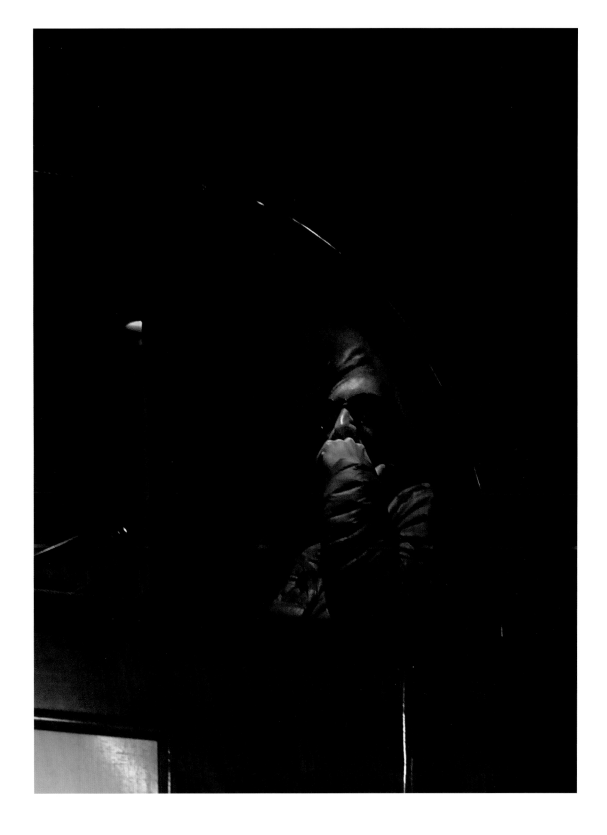

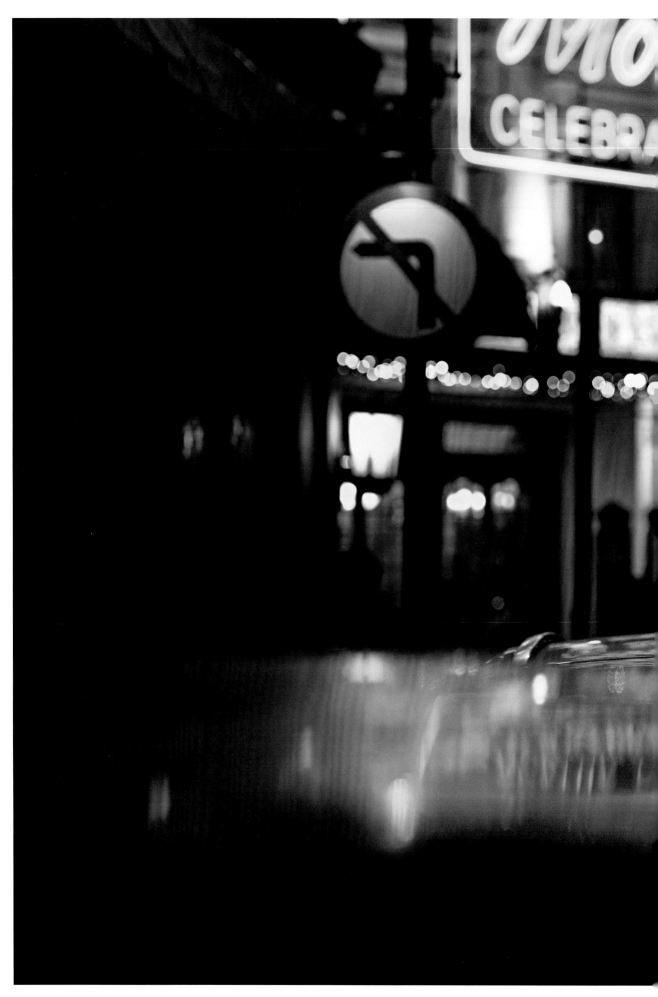

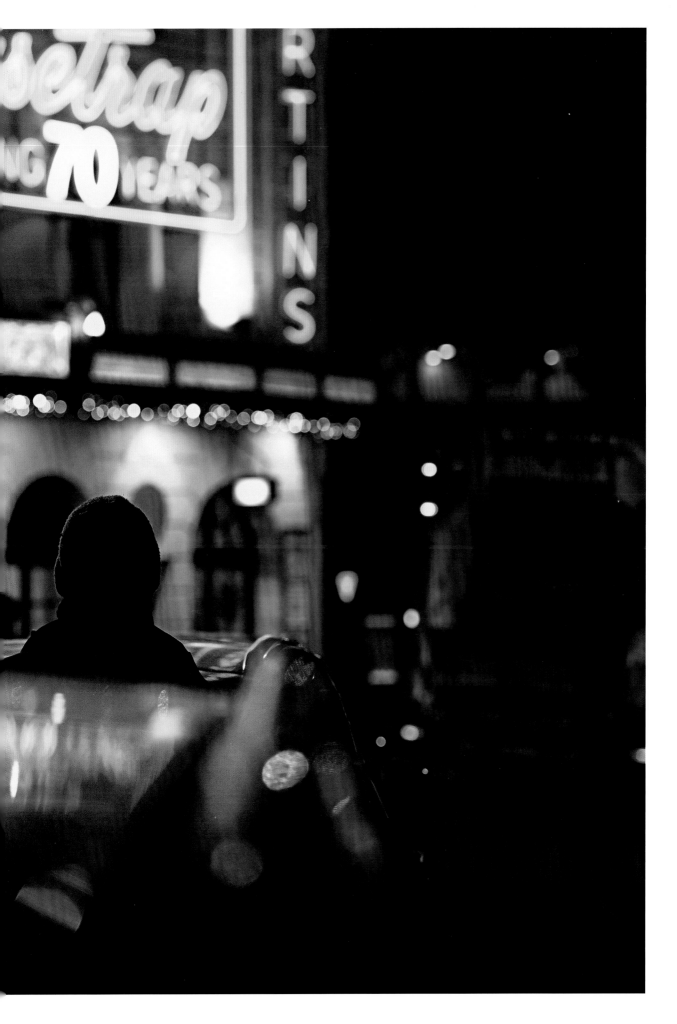

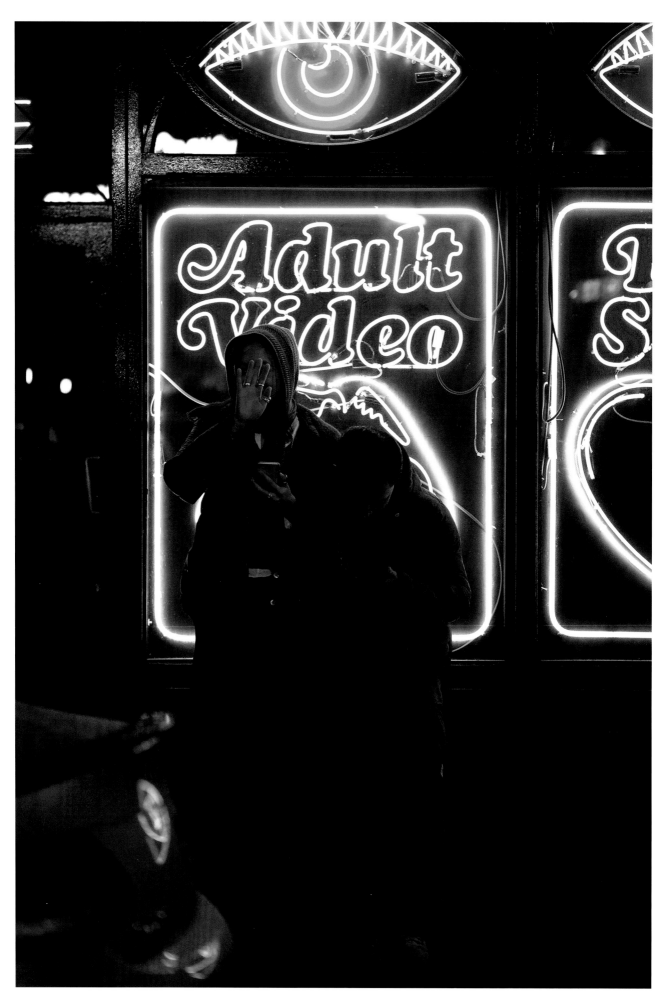

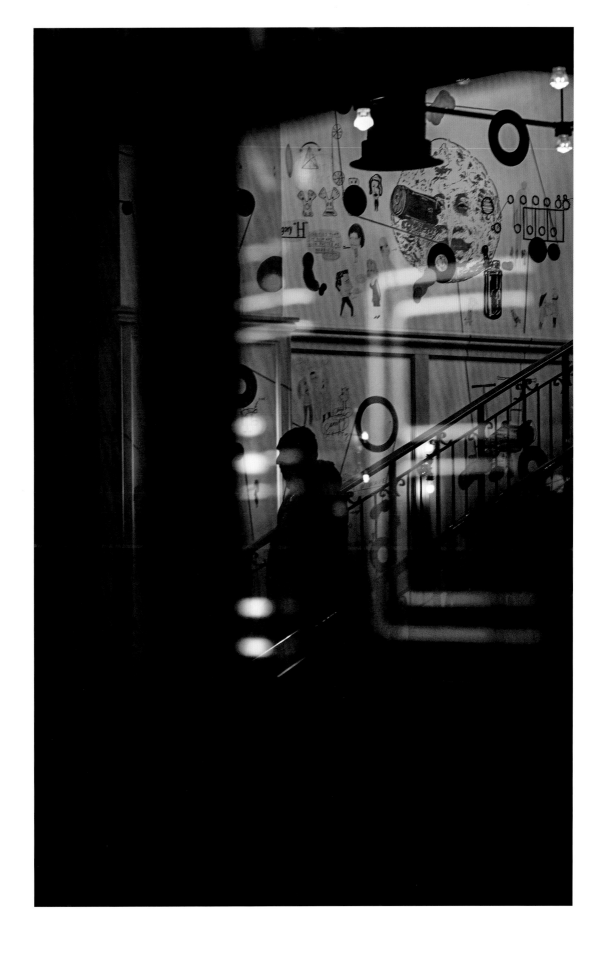

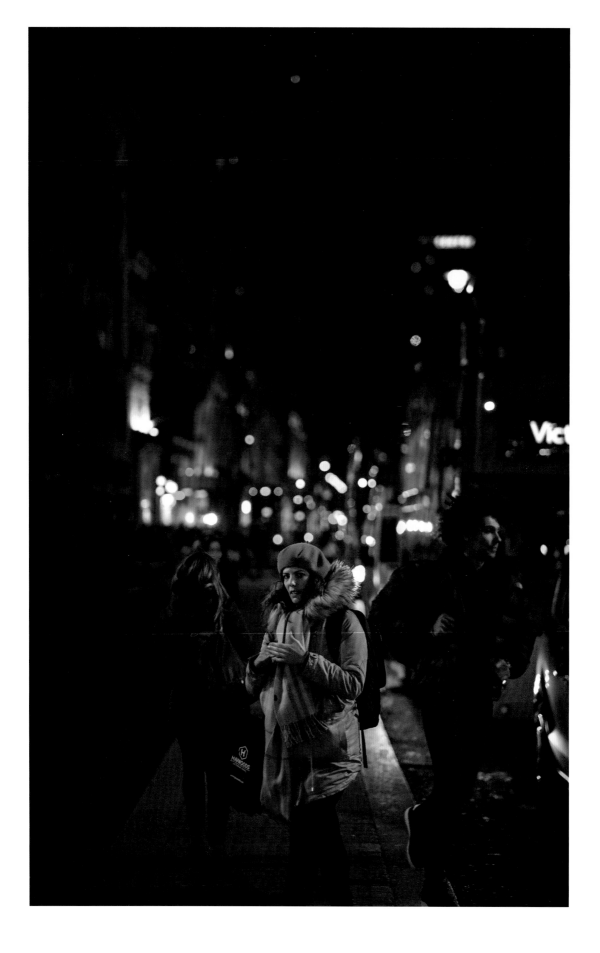

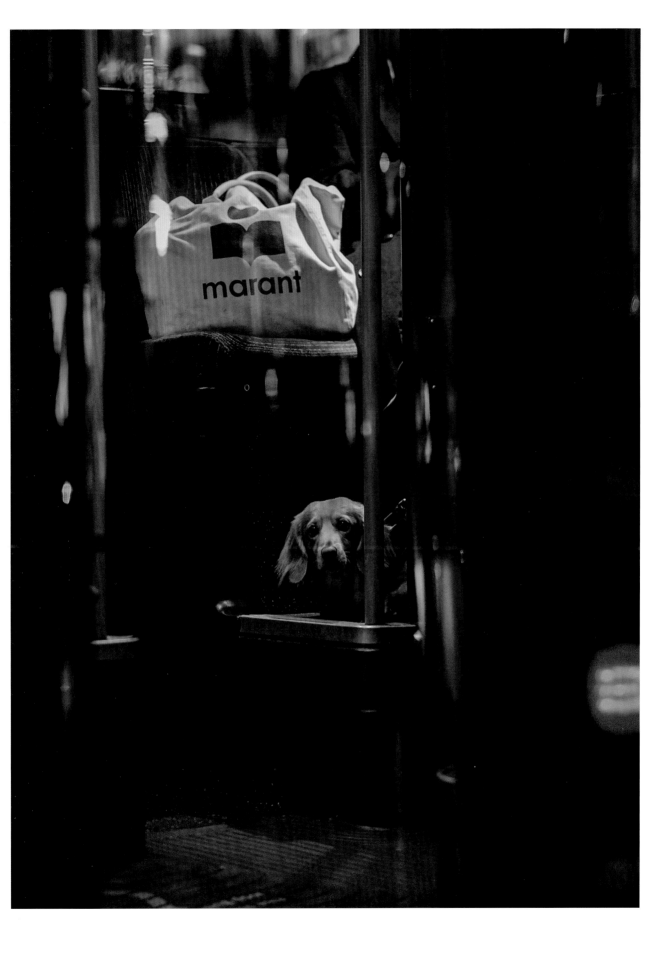

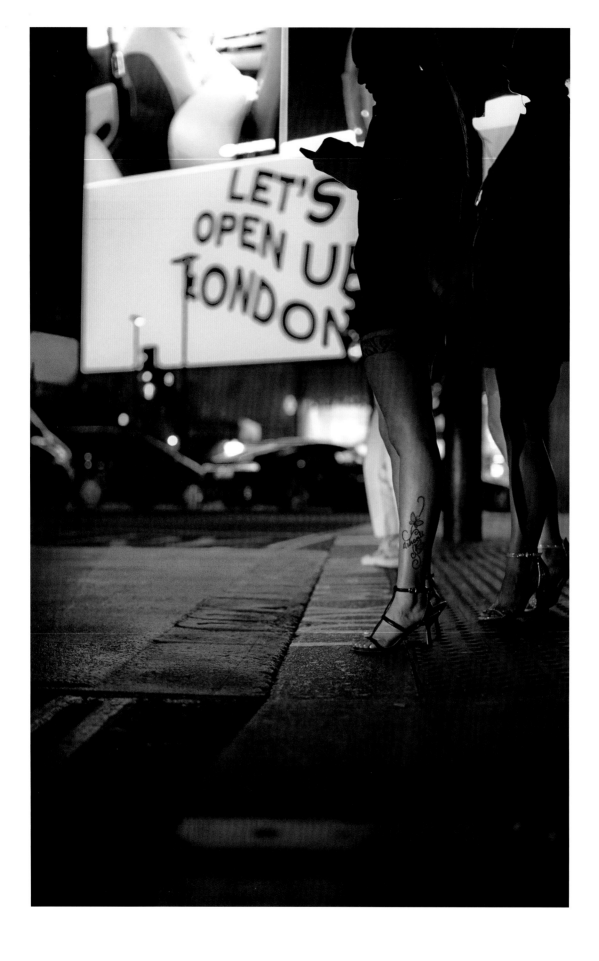

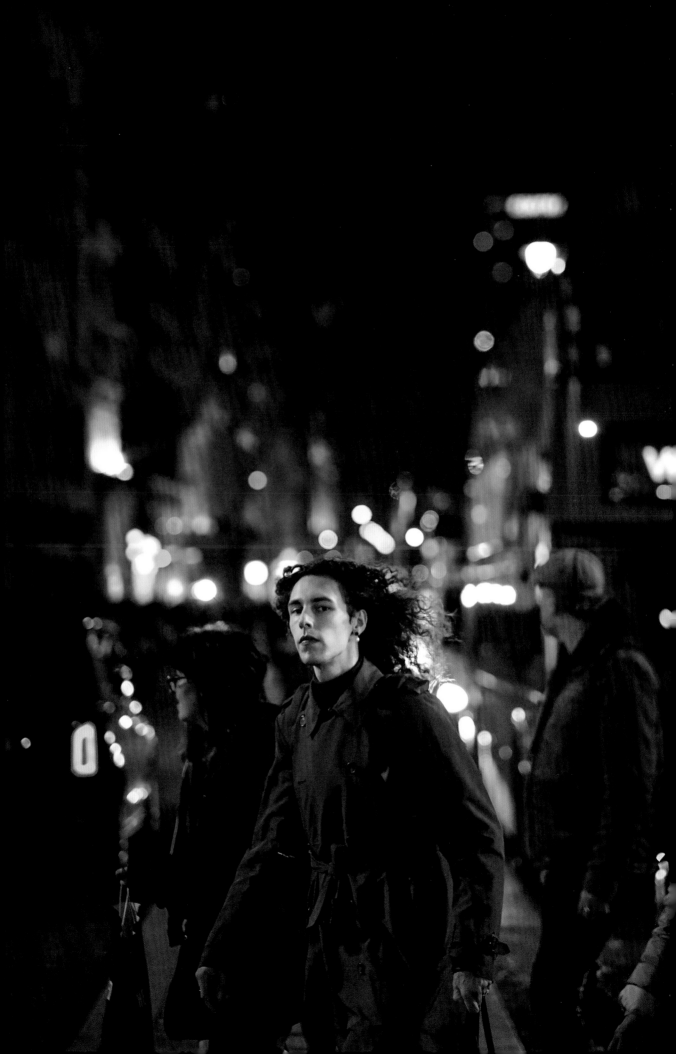

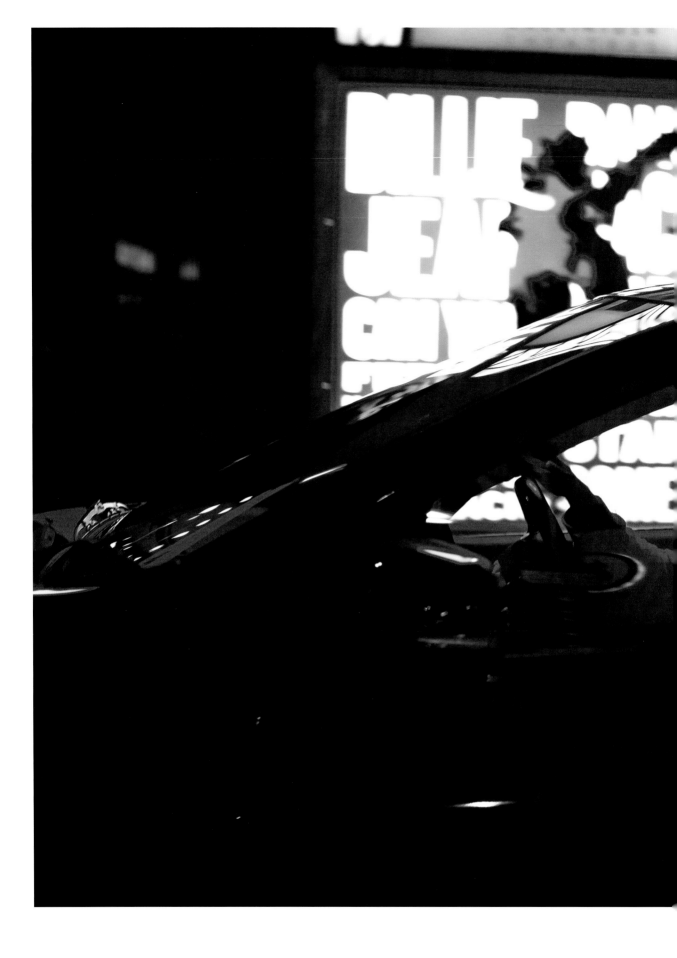

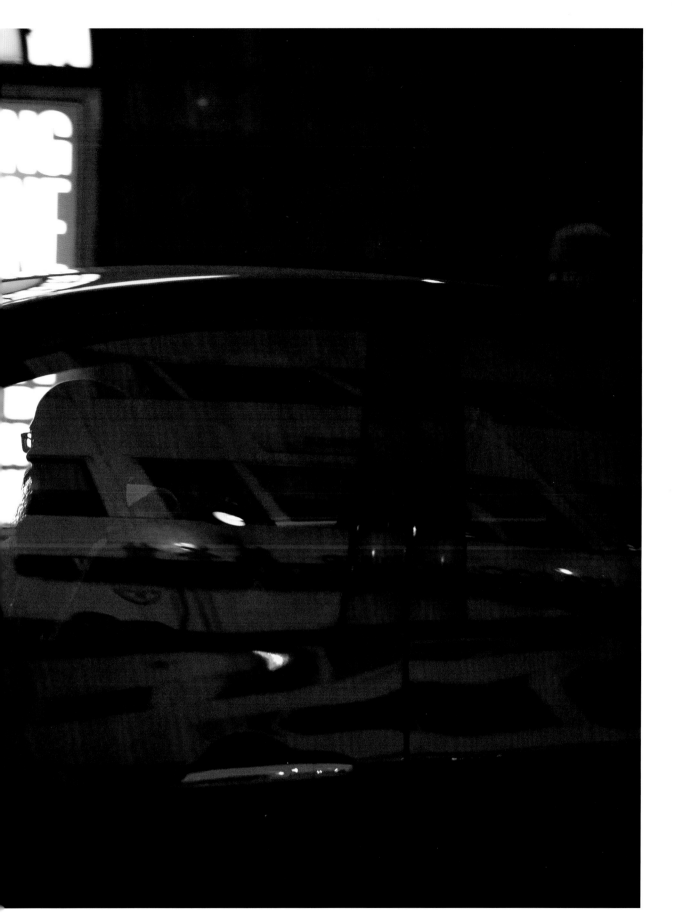

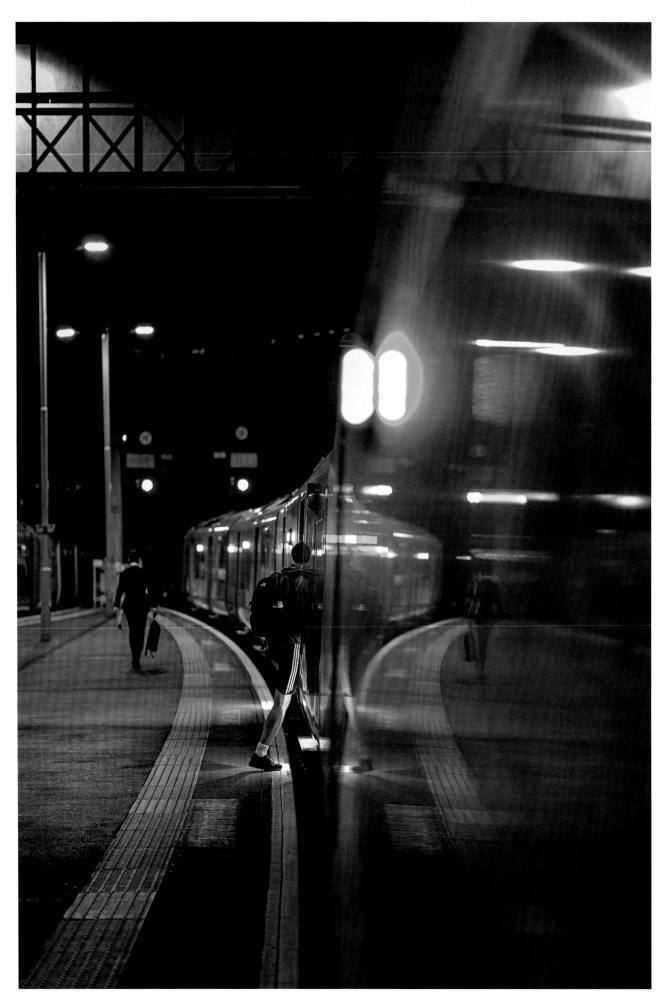

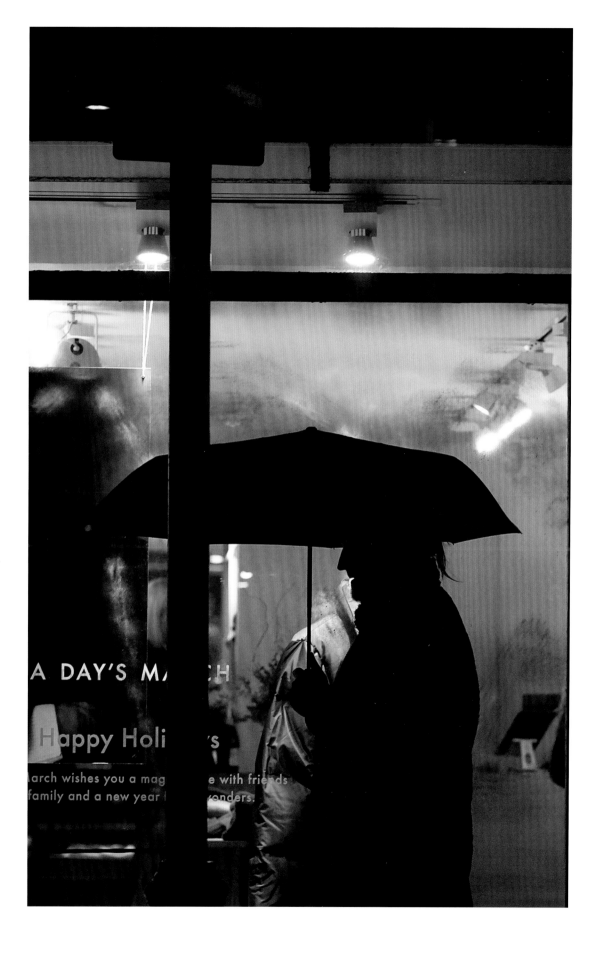

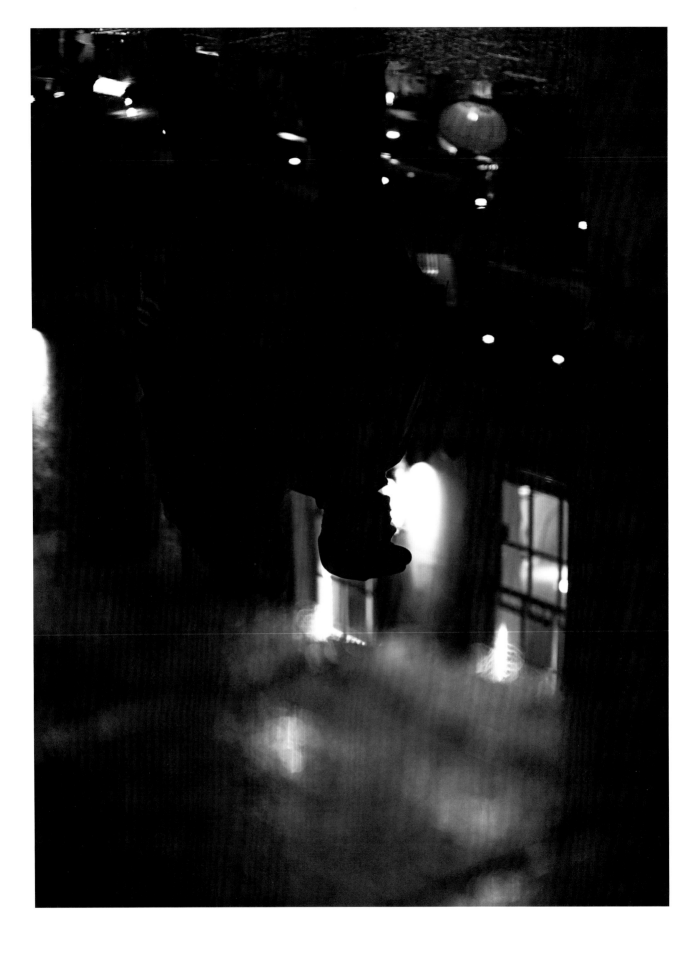

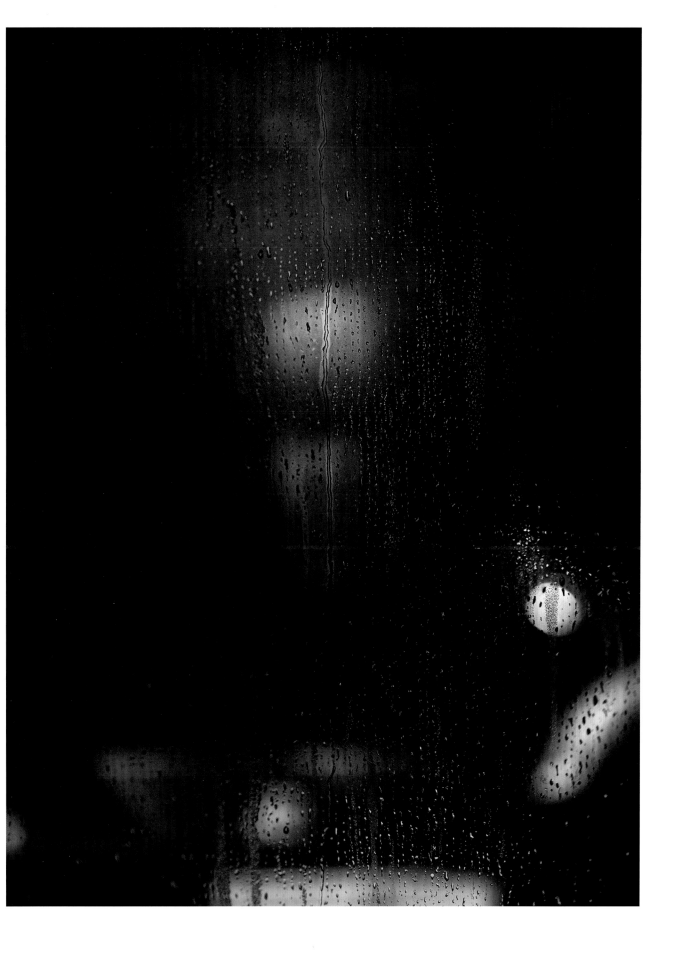

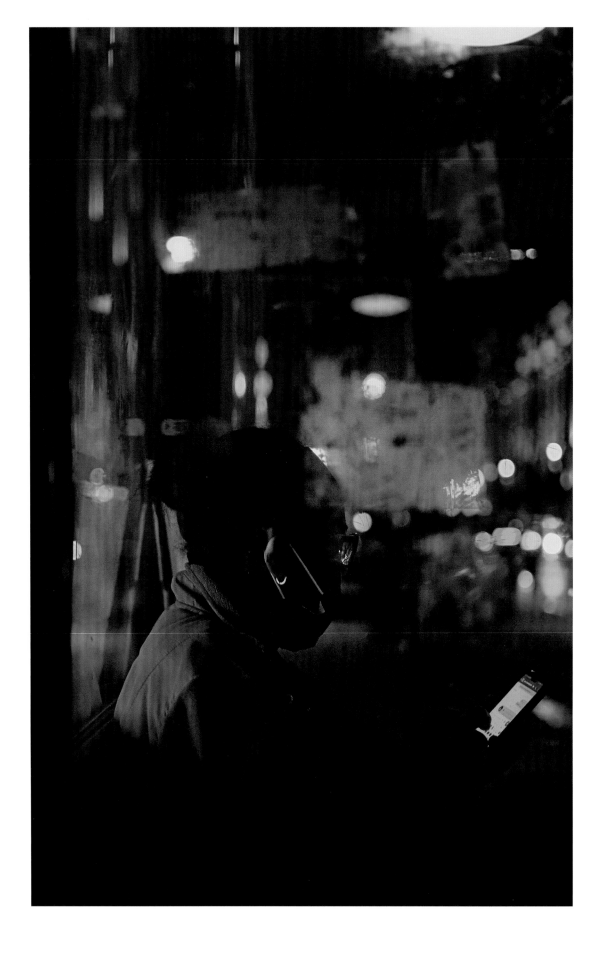

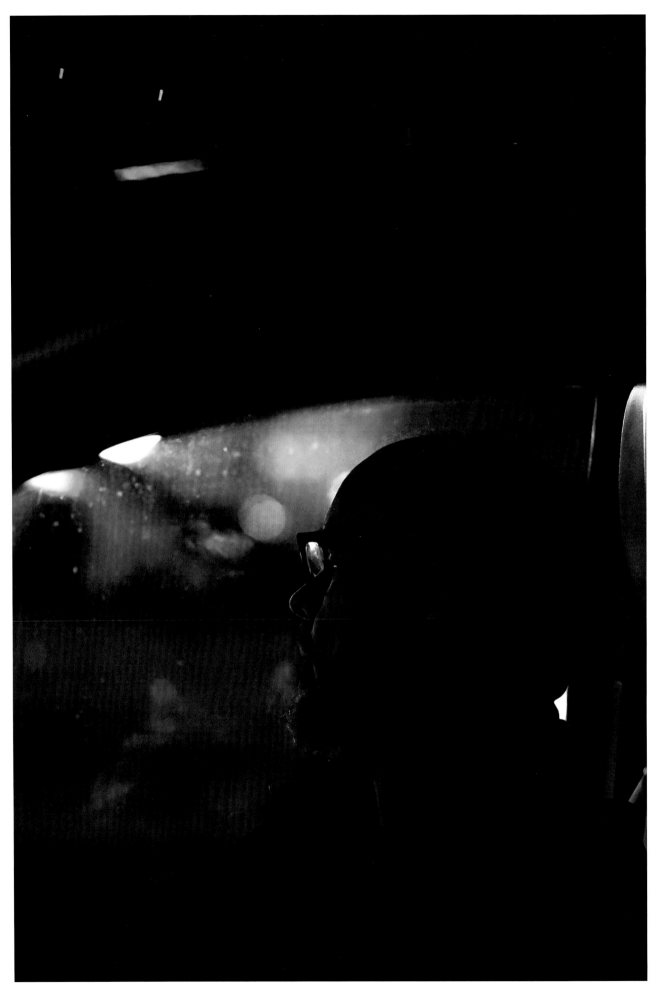

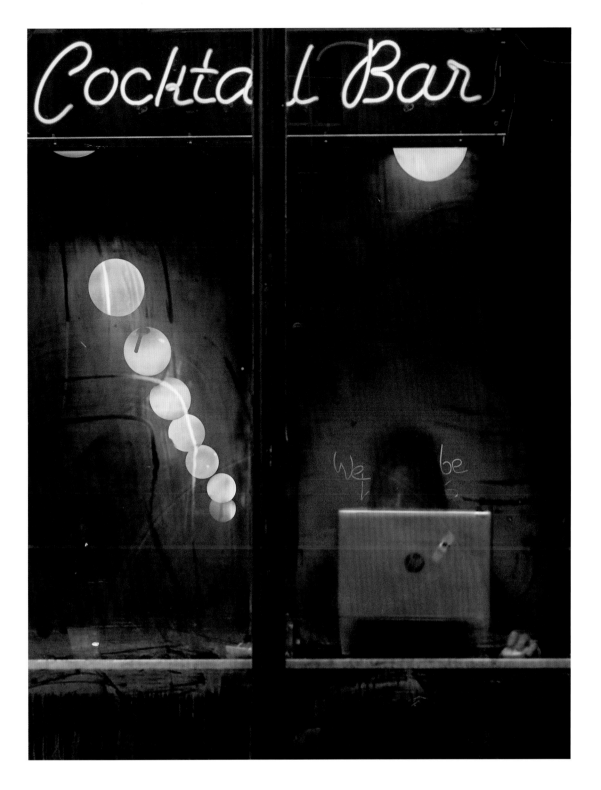

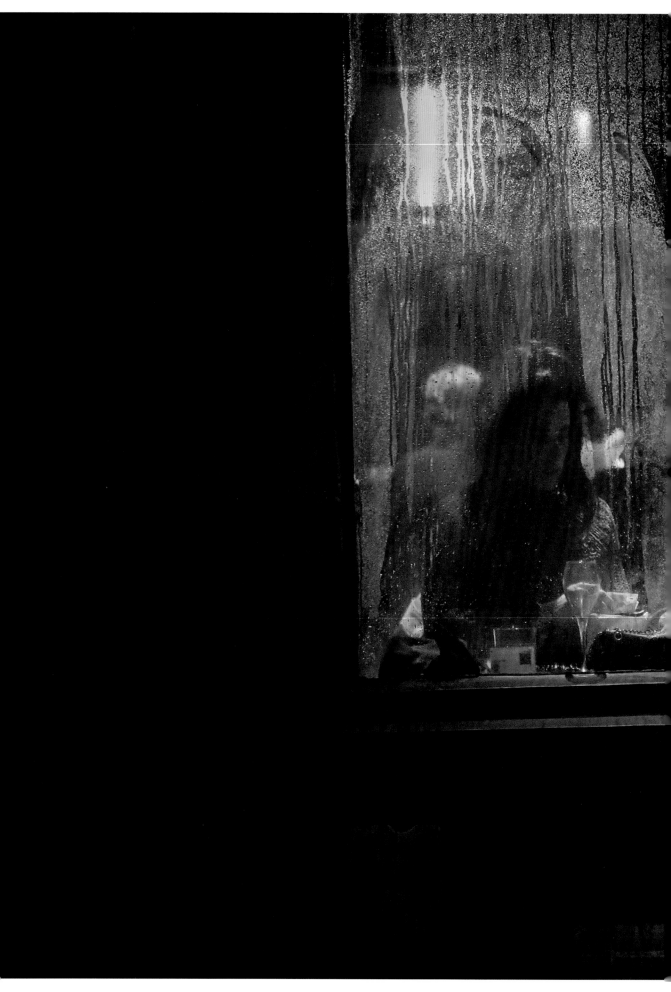

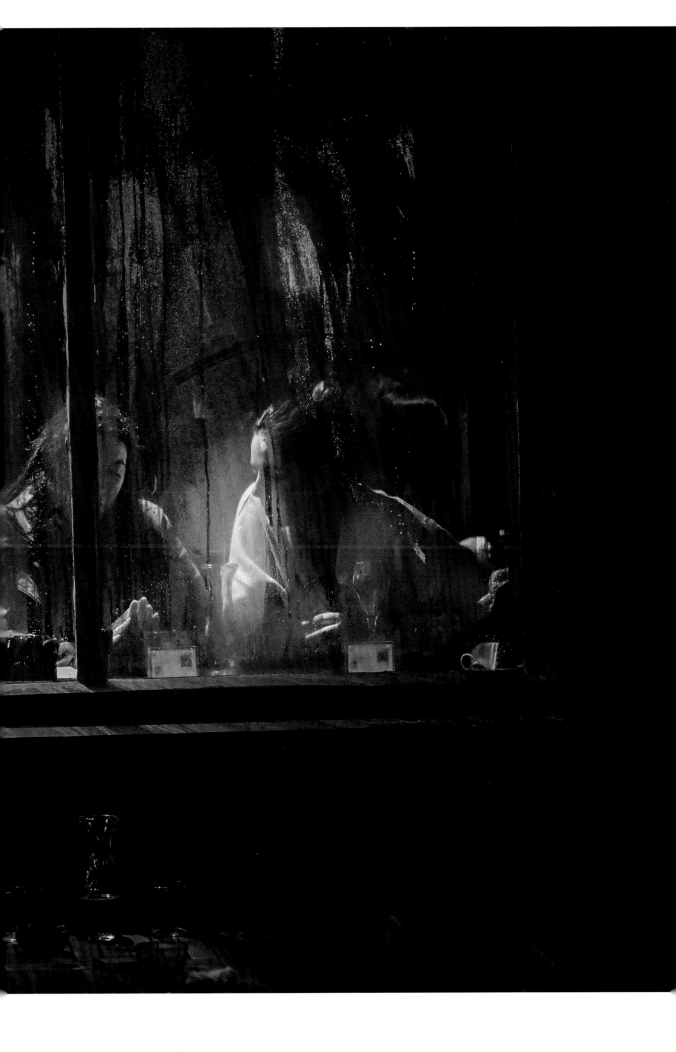

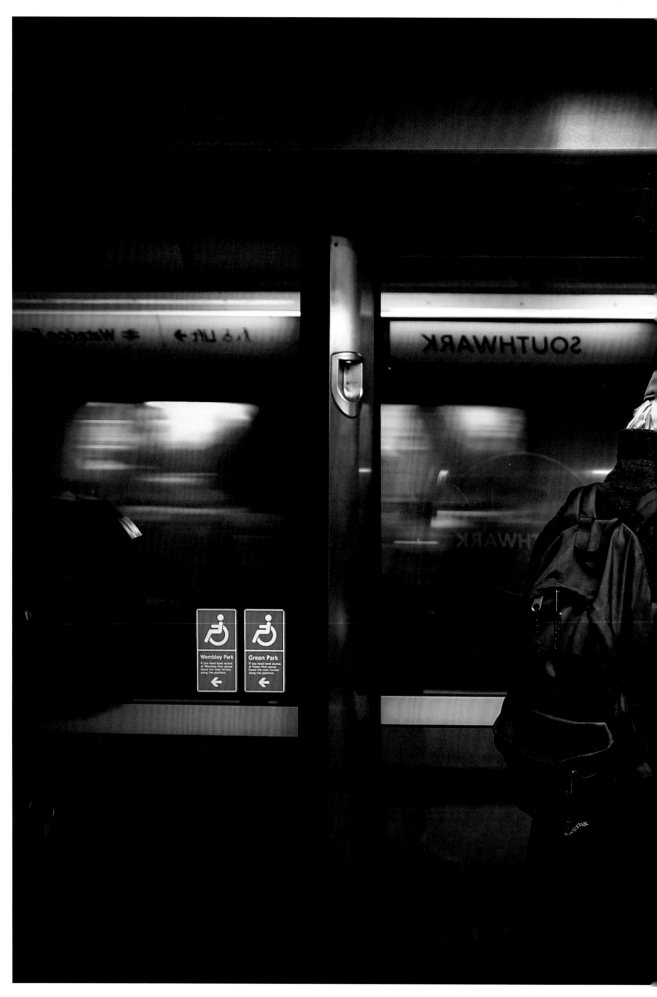

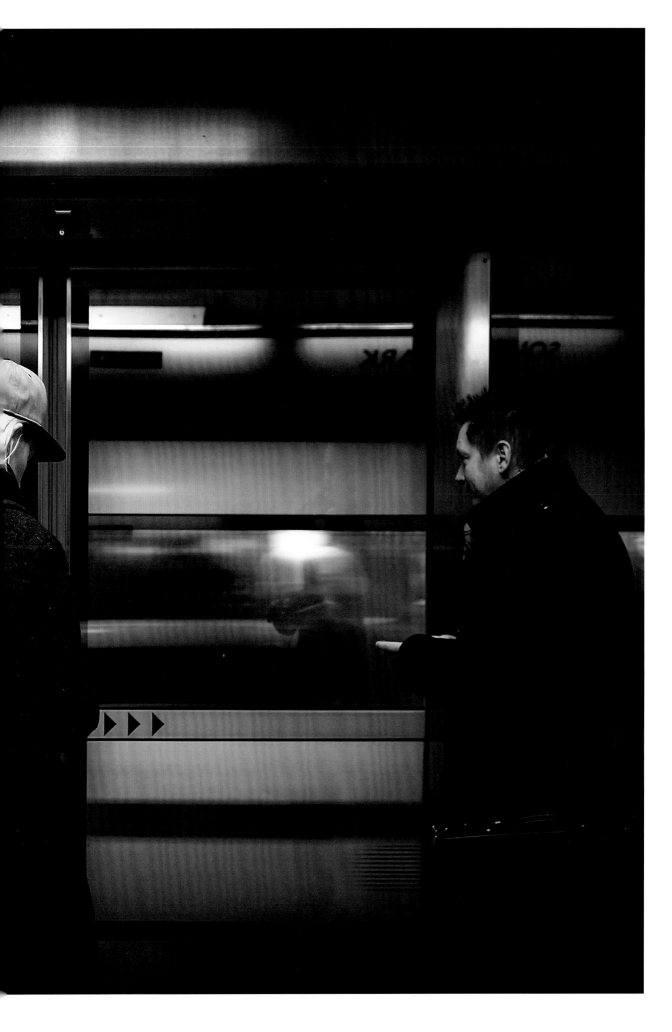

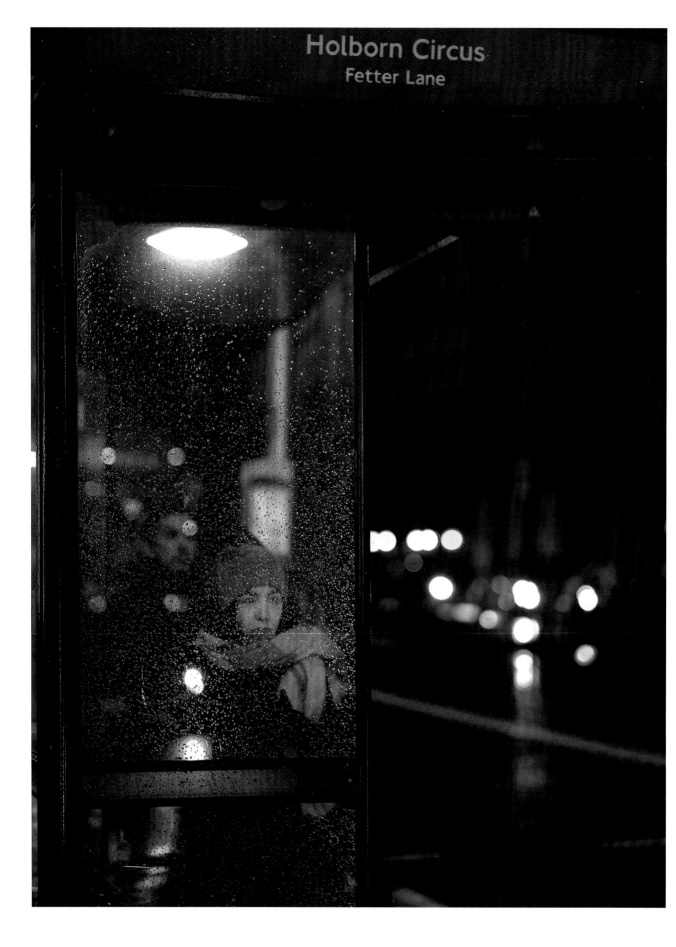

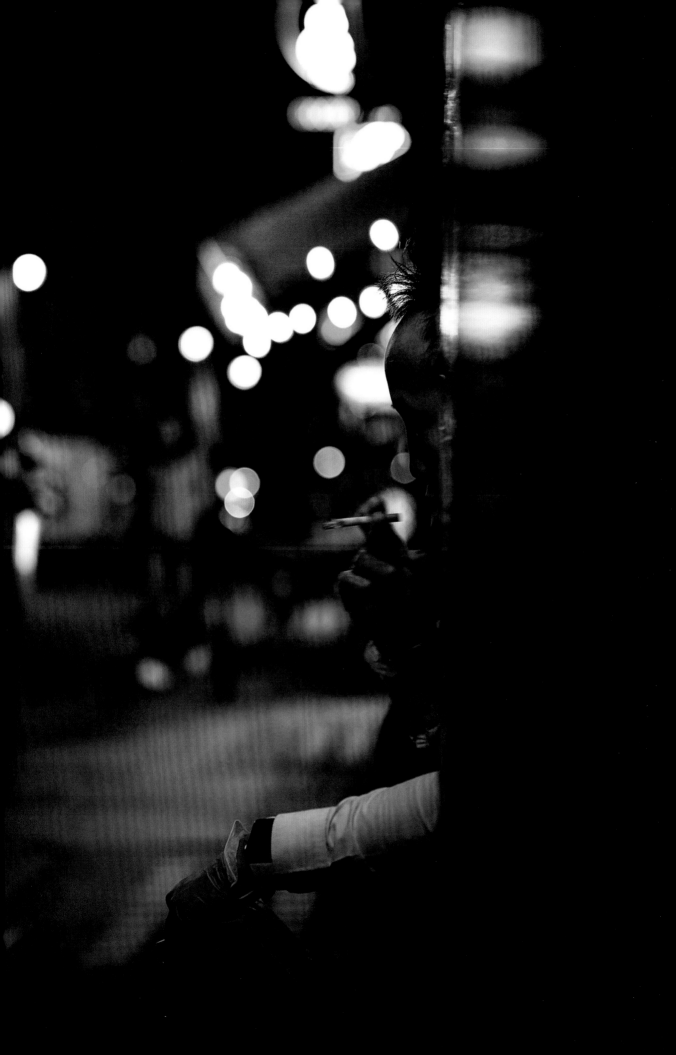

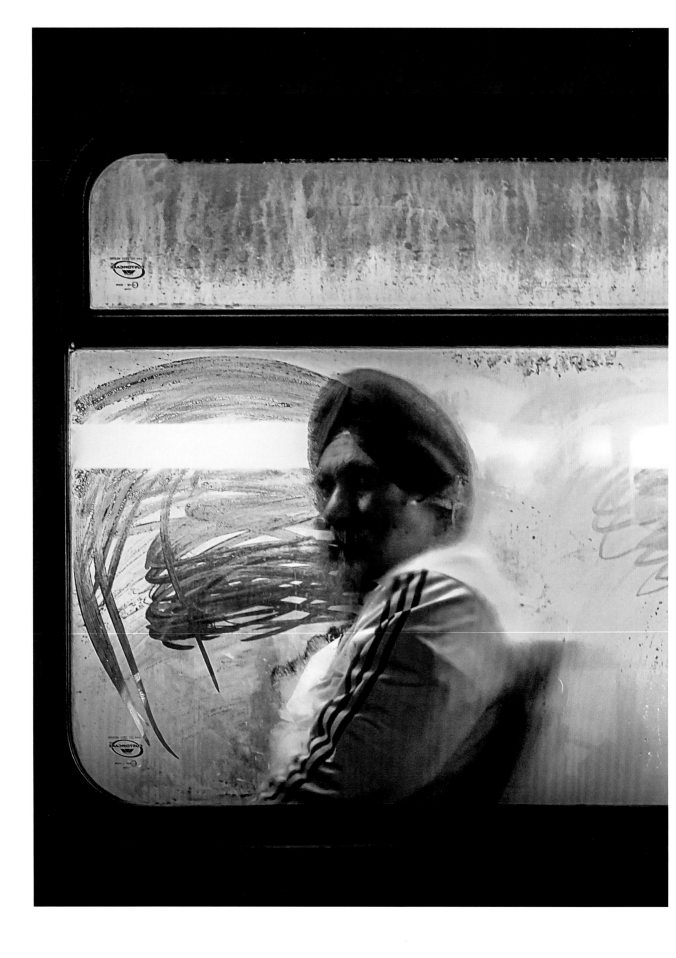

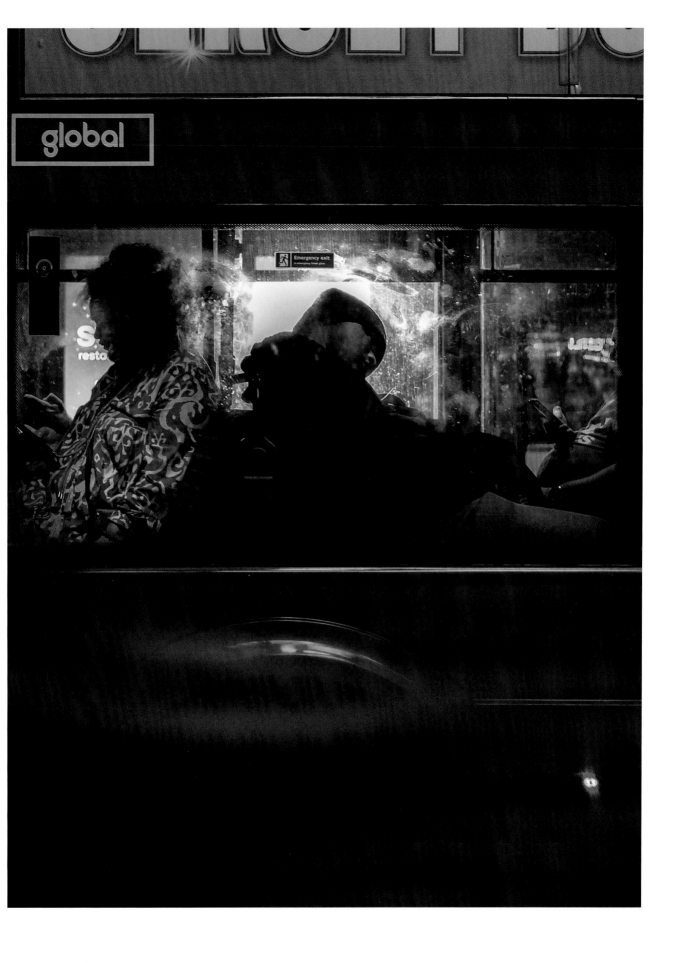

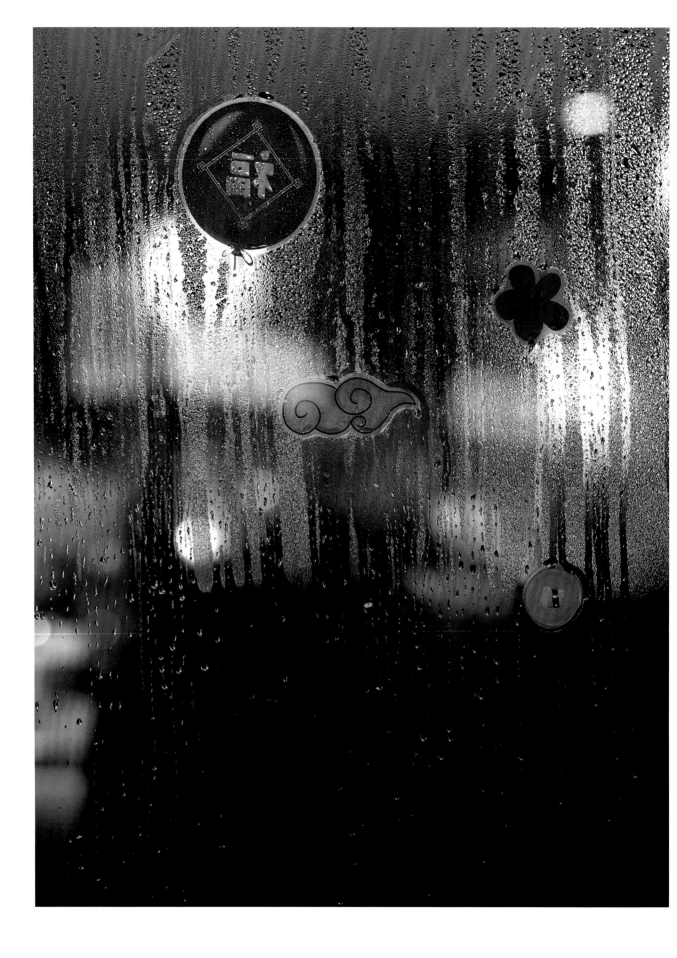

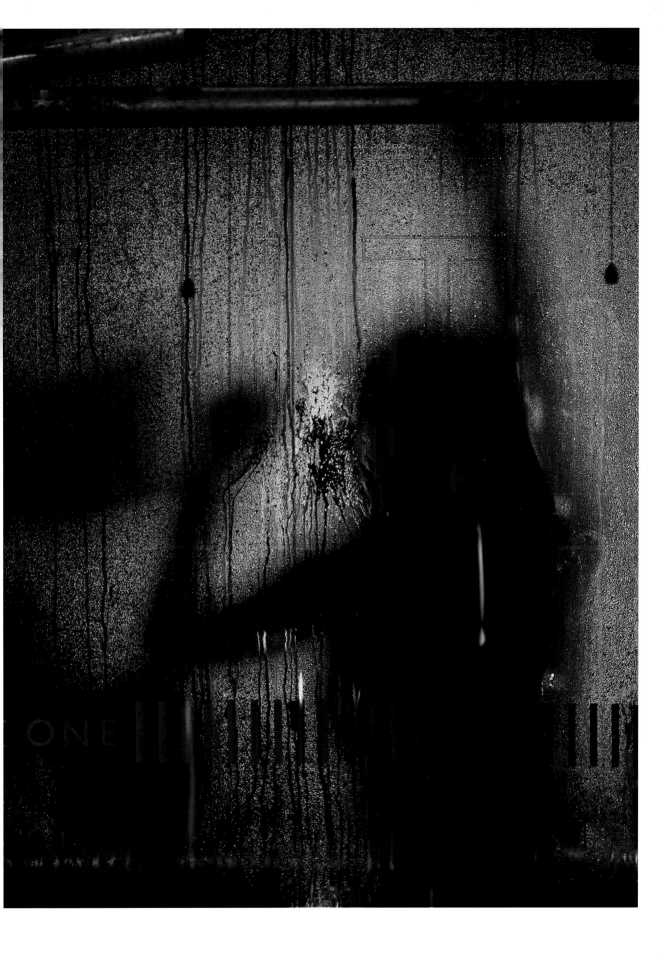

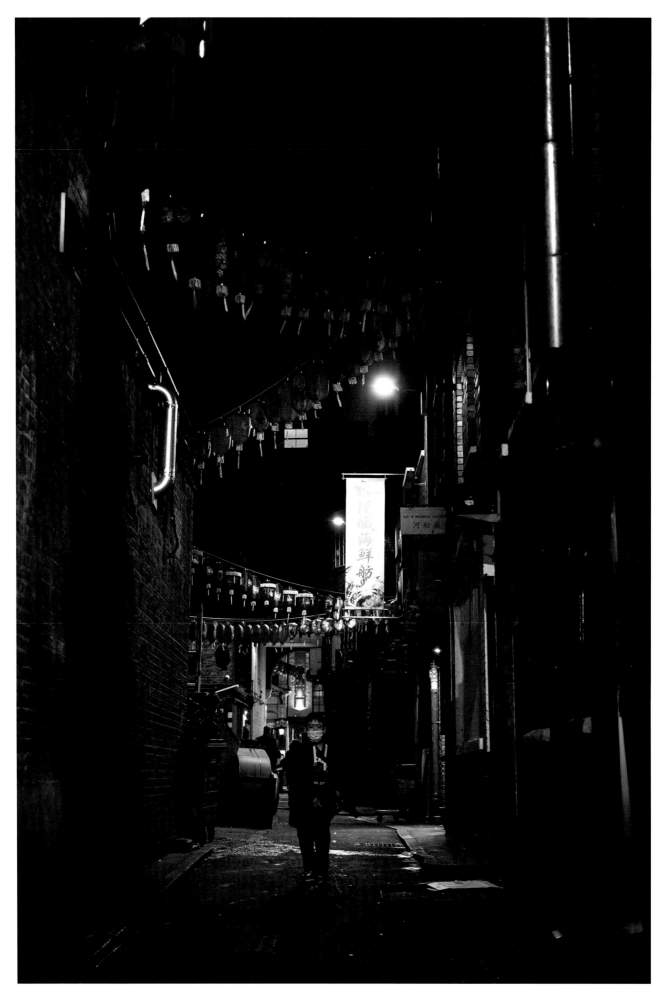

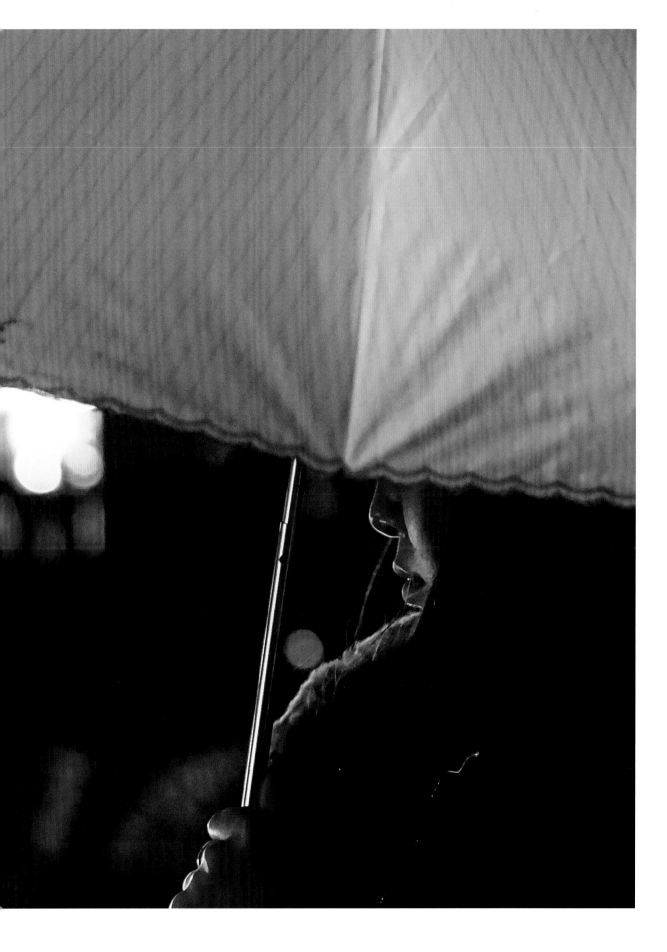

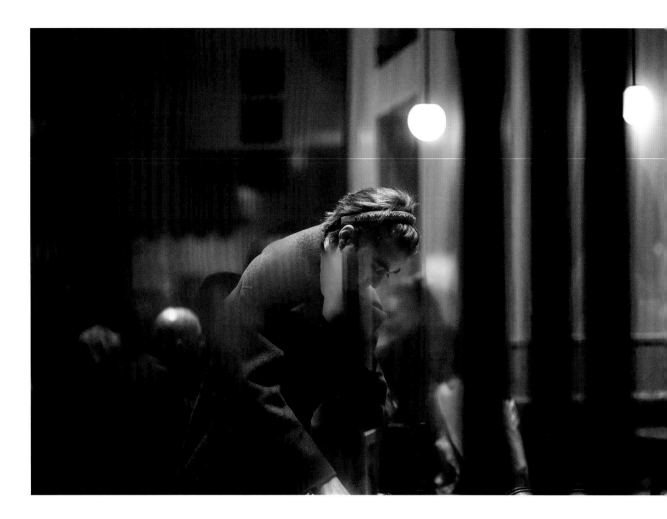

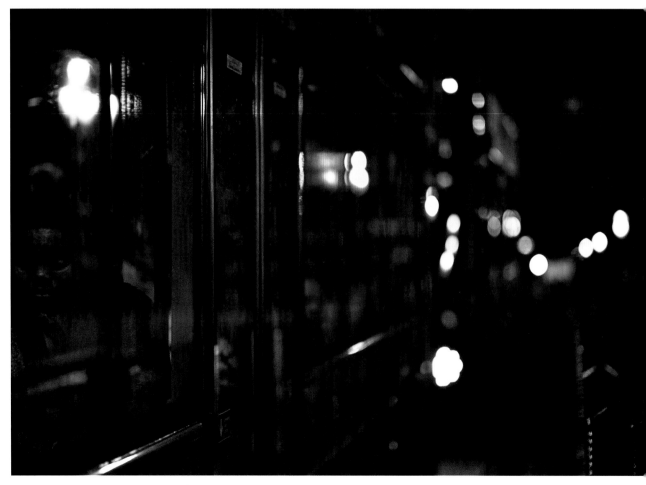

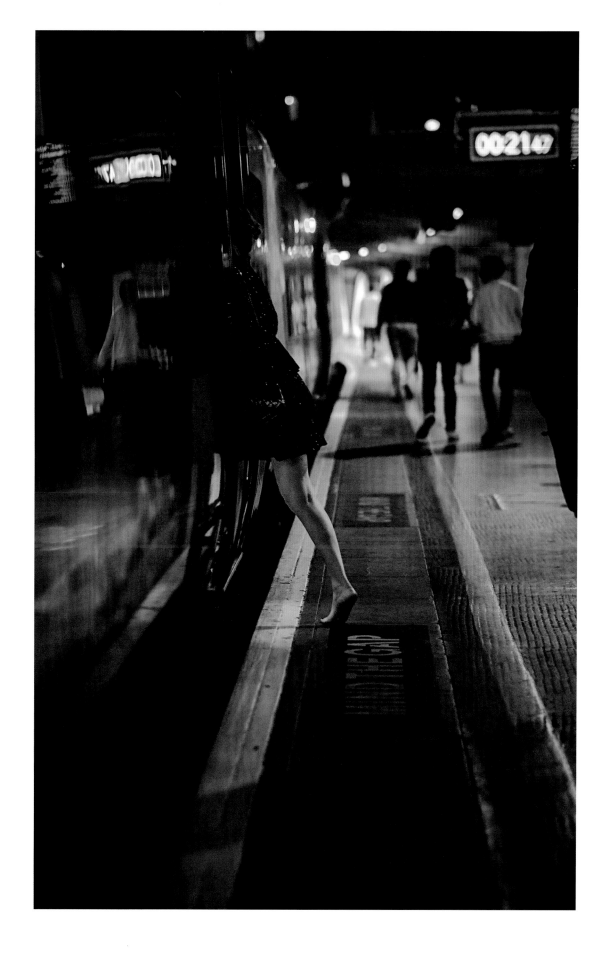

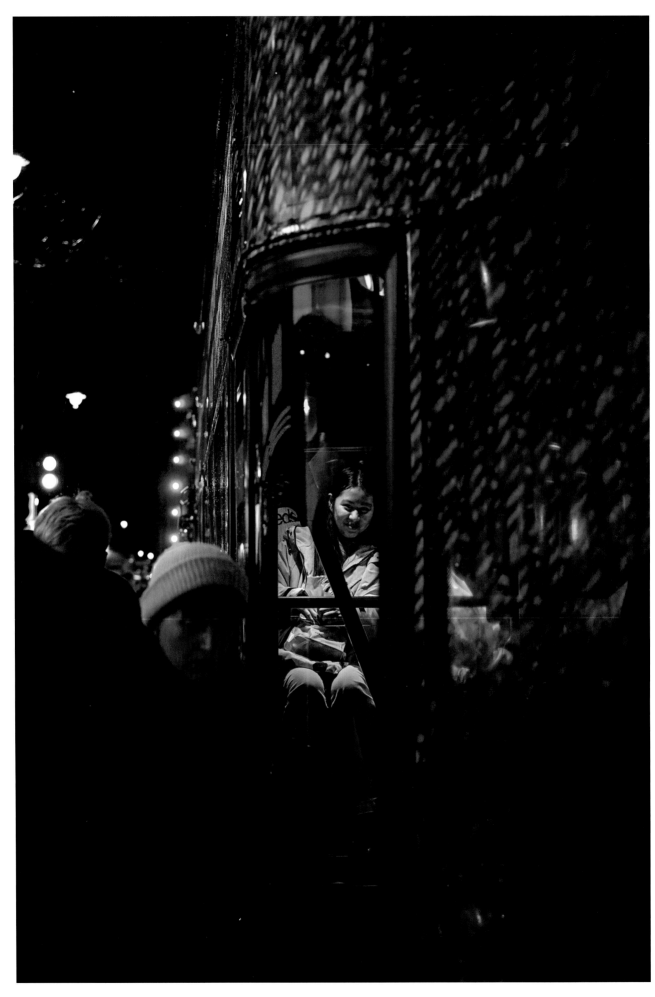

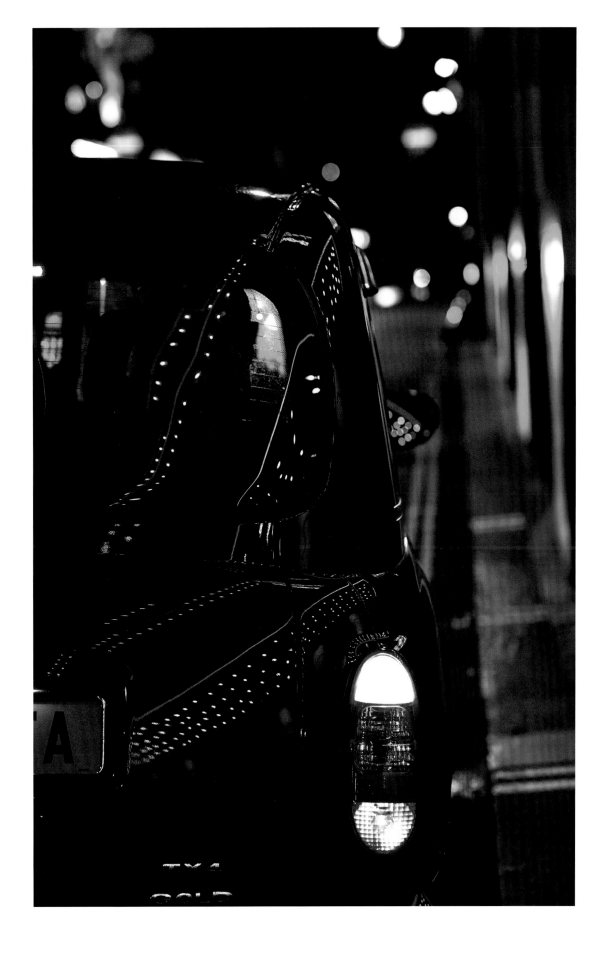

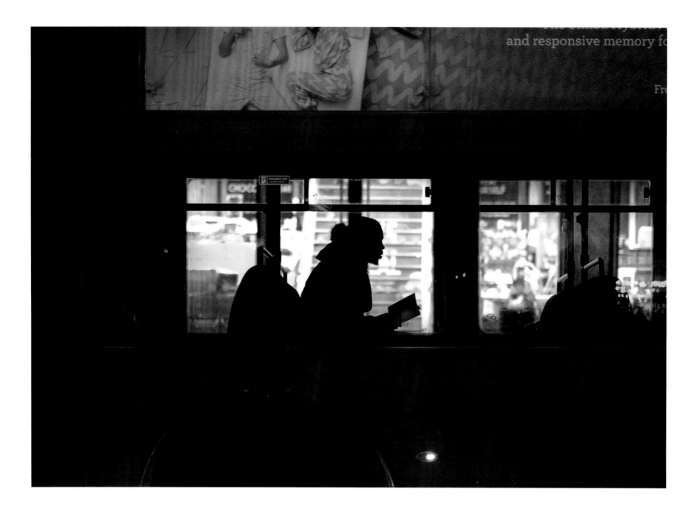

No. 57 · OXFORD STREET · 2017

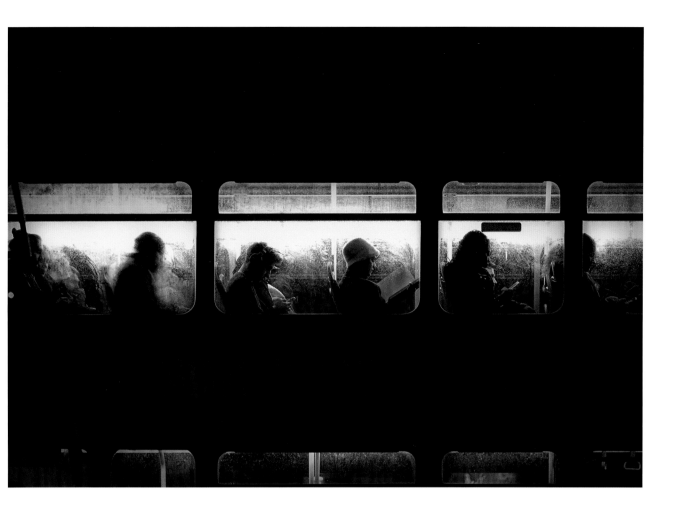

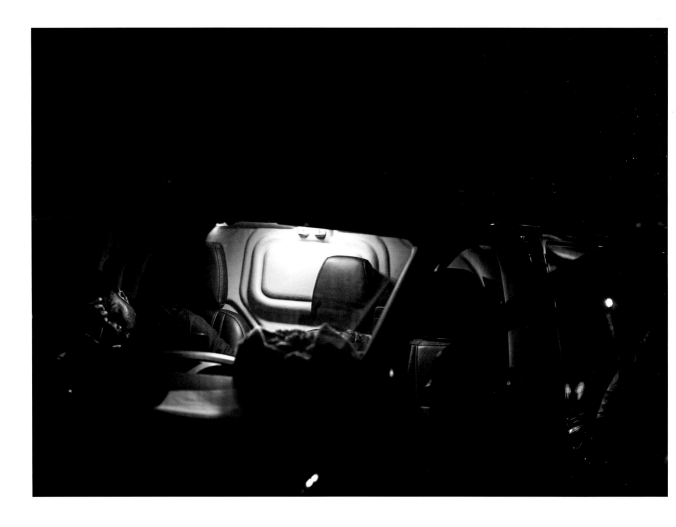

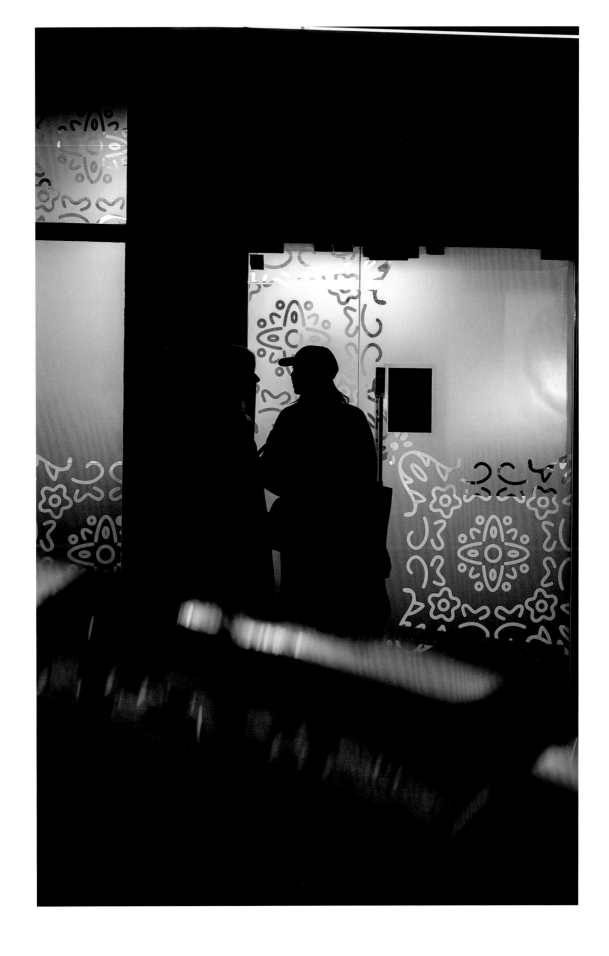

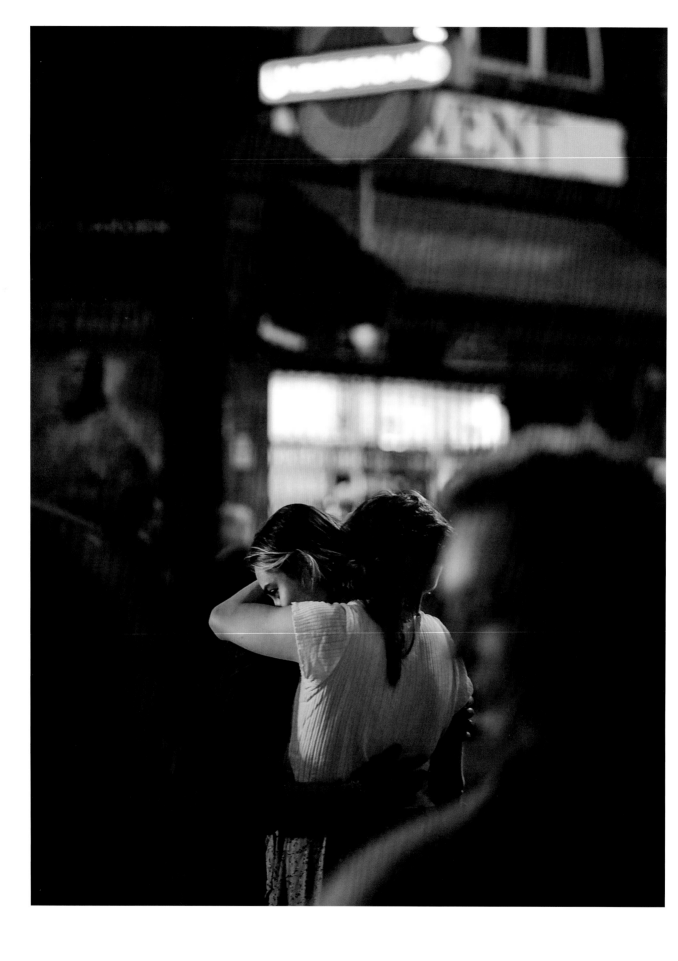

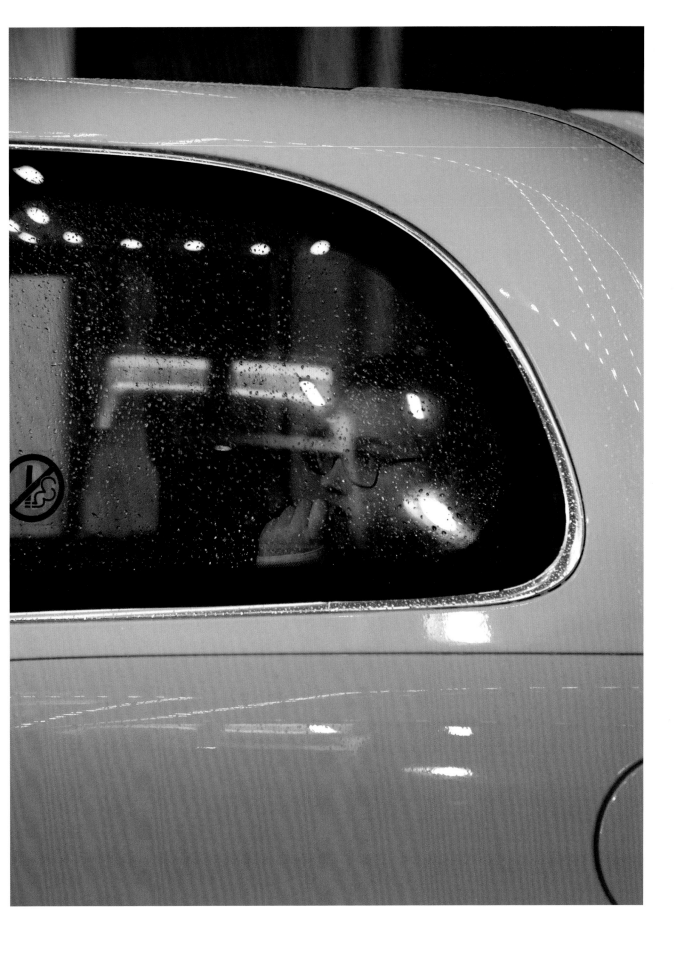

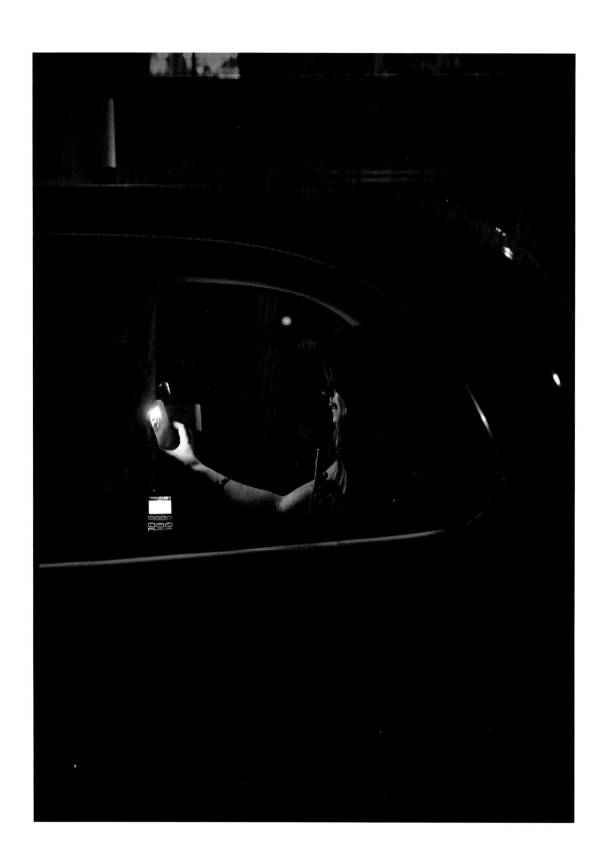

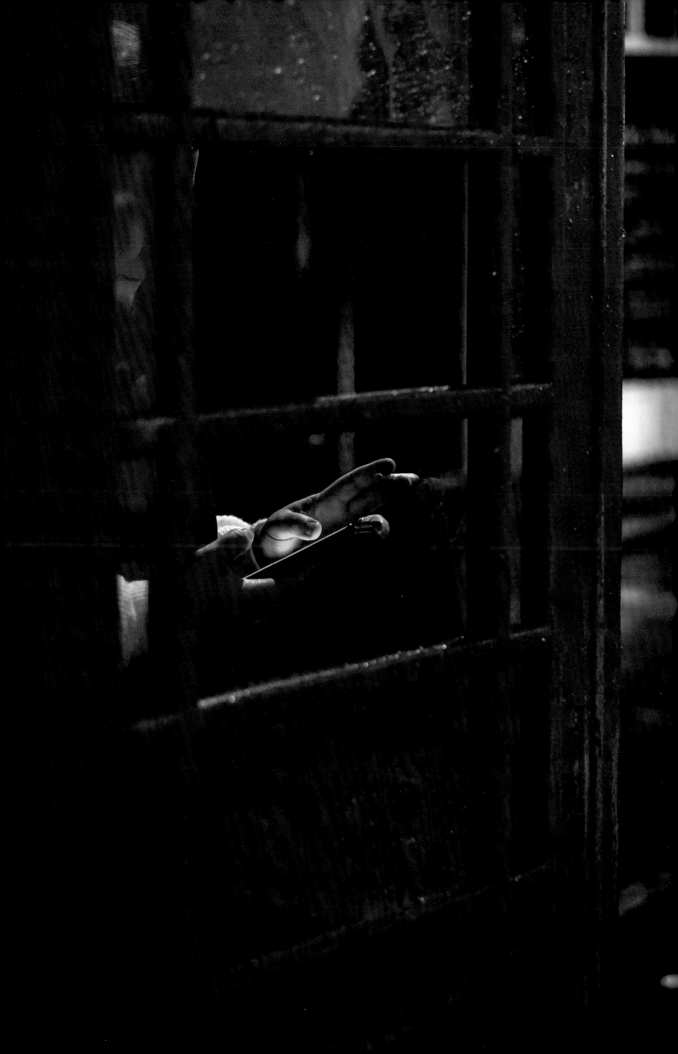

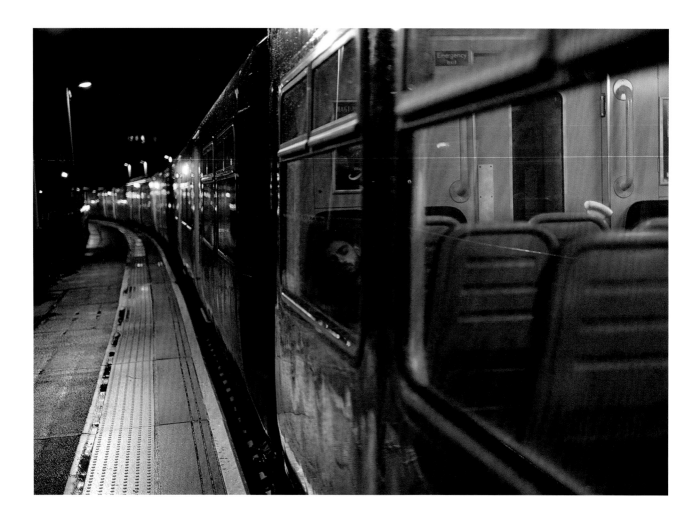

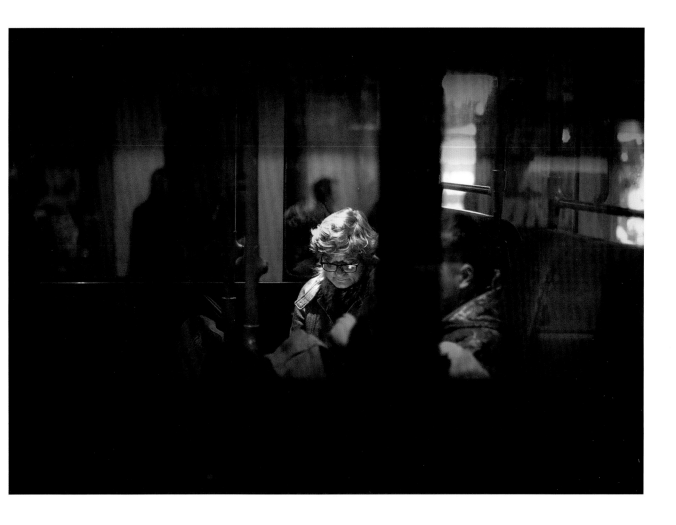

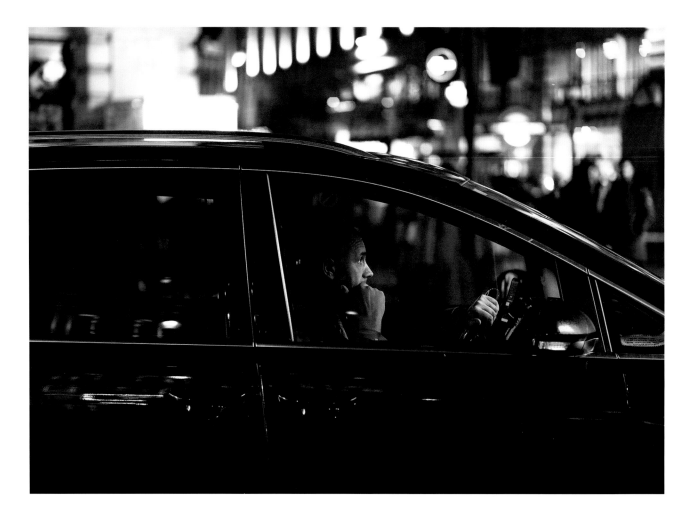

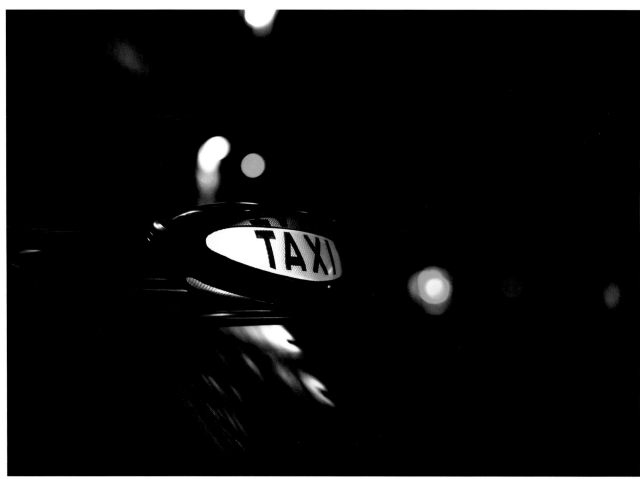

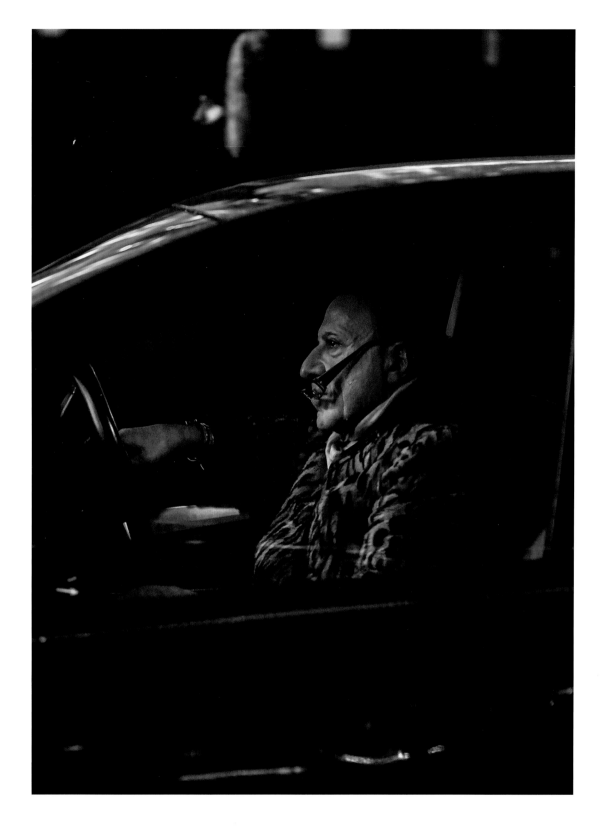

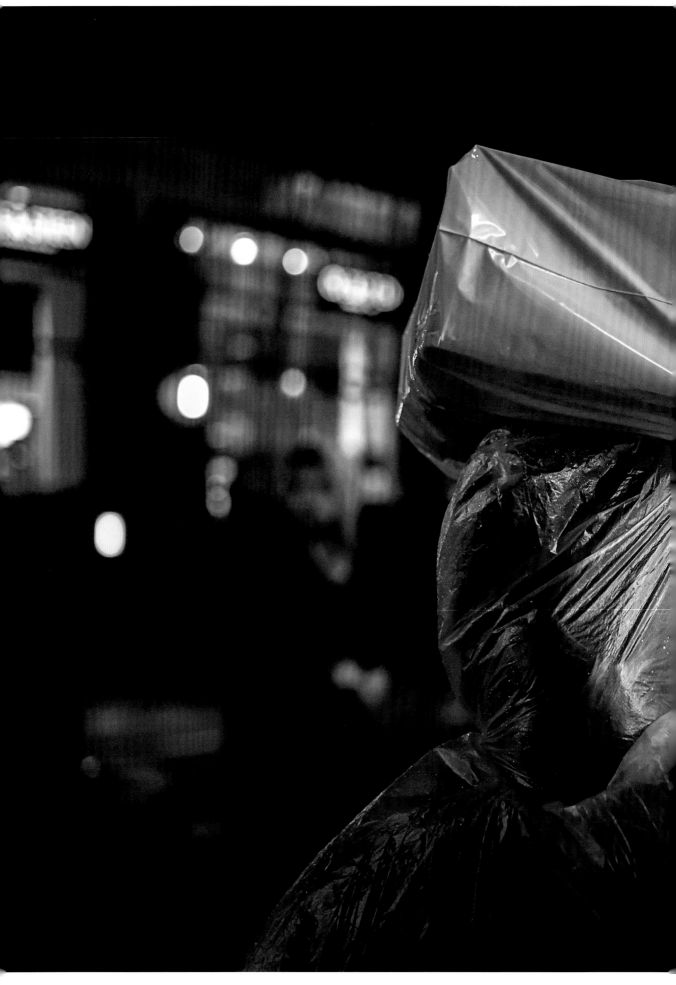

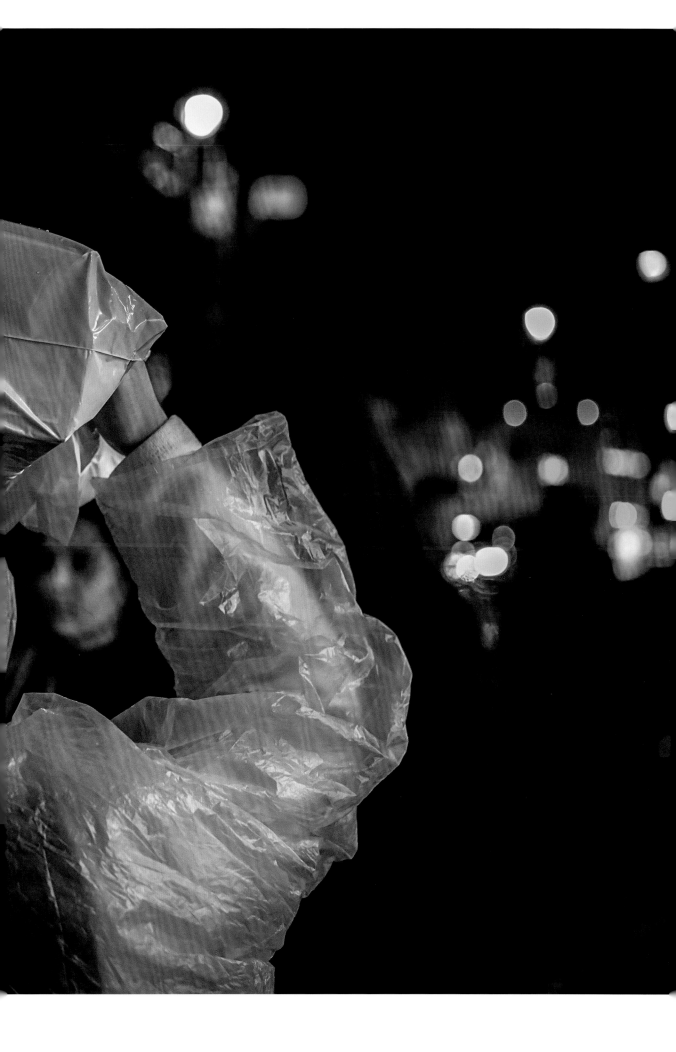

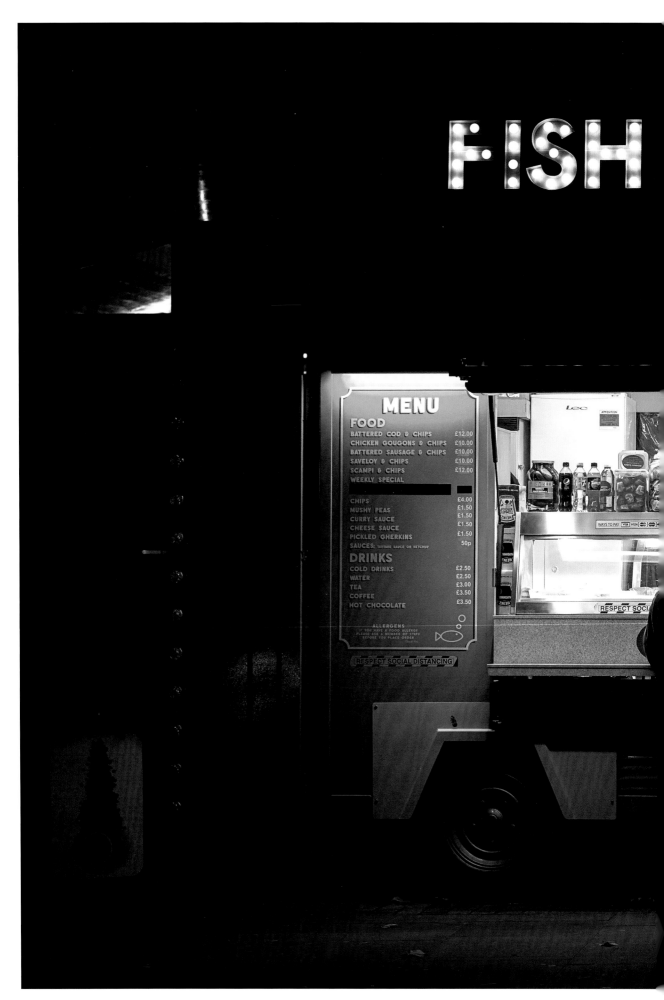

& CHIPS

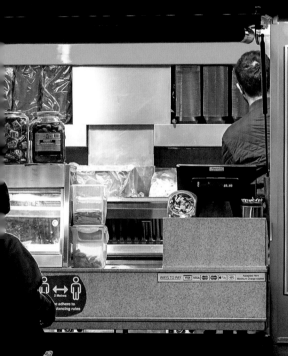

MENU

FOOD

BATTERED COD & CHIPS	£12.00
CHICKEN GOUGONS & CHIPS	£10.00
BATTERED SAUSAGE & CHIPS	£10.00
SAVELOY & CHIPS	£10.00
SCAMPI & CHIPS	£12.00
WEEKLY SPECIAL	
CHIPS	£4.00
MUSHY PEAS	£1.50
CURRY SAUCE	£1.50
CHEESE SAUCE	£1.50
PICKLED GHERKINS	£1.50
SAUCES: TARTARE SAUCE OR KETCHUP	50p

DRINKS

COLD DRINKS	£2.50
WATER	£2.50
TEA	£3.00
COFFEE	£3.50
HOT CHOCOLATE	£3.50

ALLERGENS
IF YOU HAVE A FOOD ALLERGY
PLEASE ASK A MEMBER OF STAFF
BEFORE YOU PLACE ORDER.

RESPECT SOCIAL DISTANCING

WAYS TO PAY VISA VISA Accepted Here Minimum Charge Applies

2 Metres
e adhere to
stancing rules

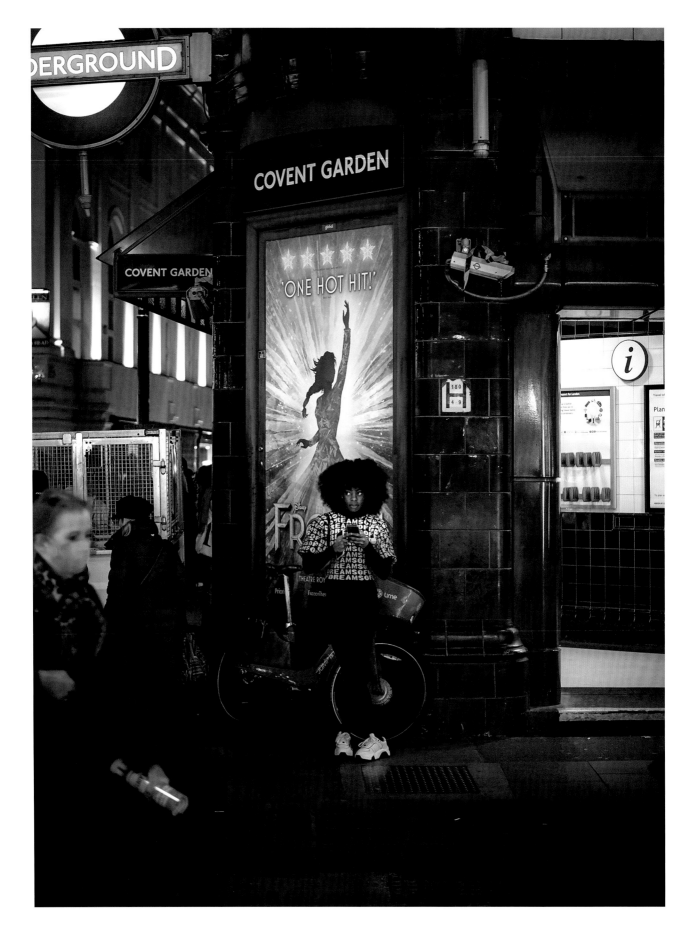

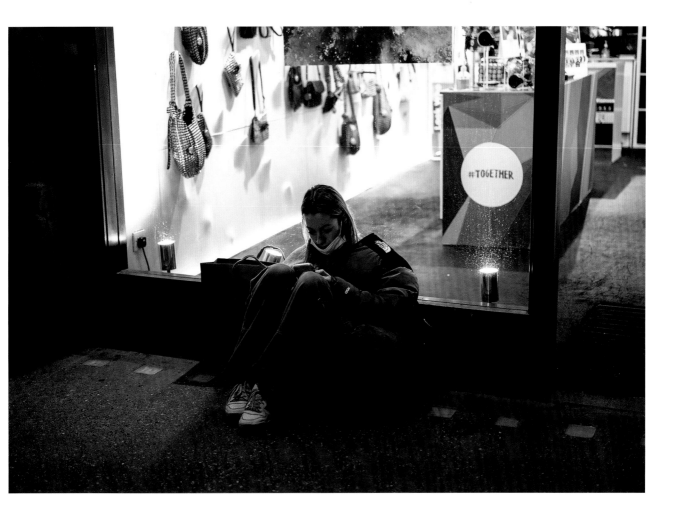

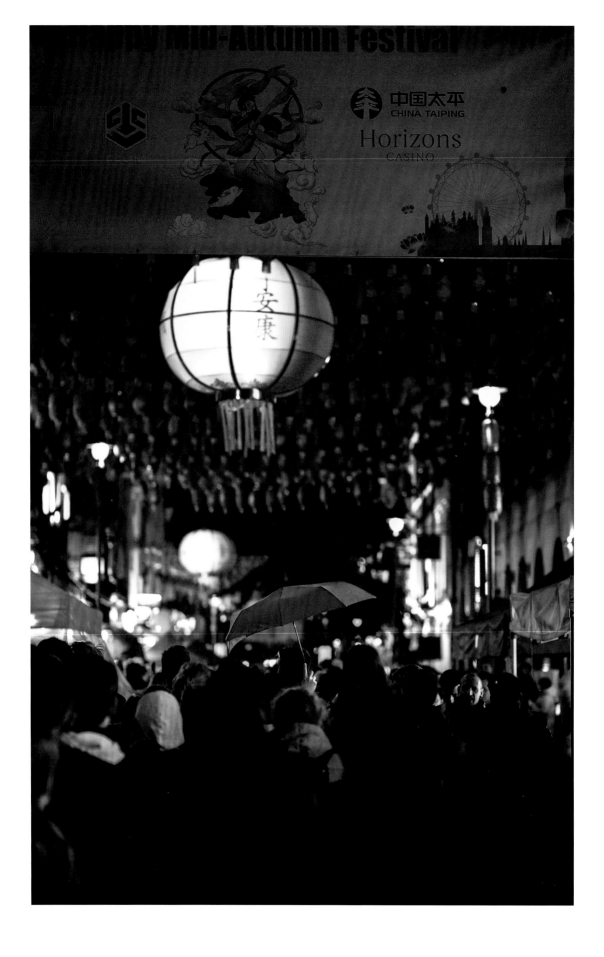

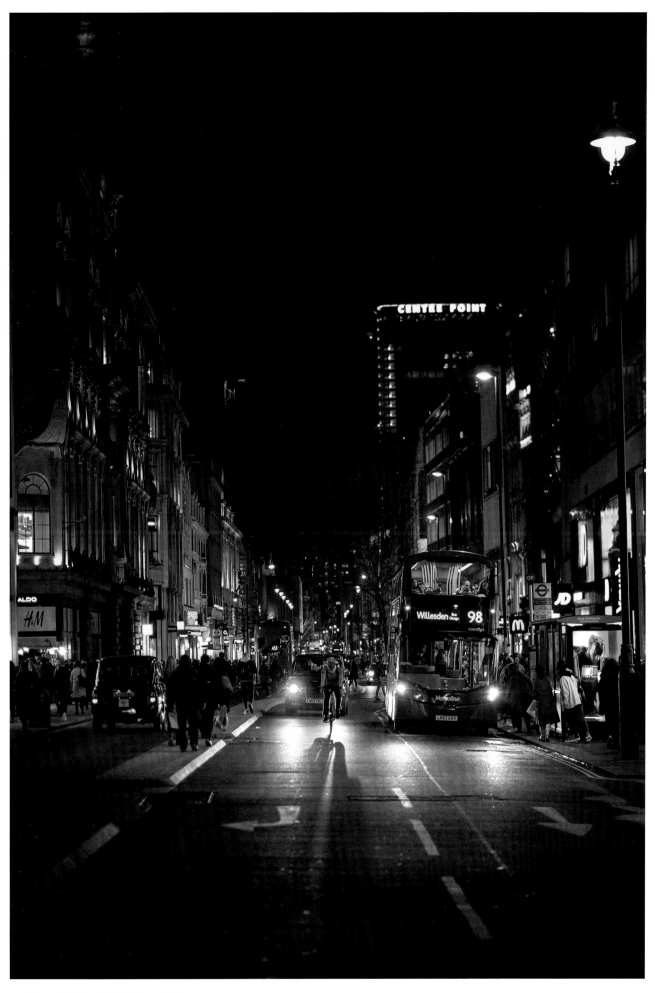

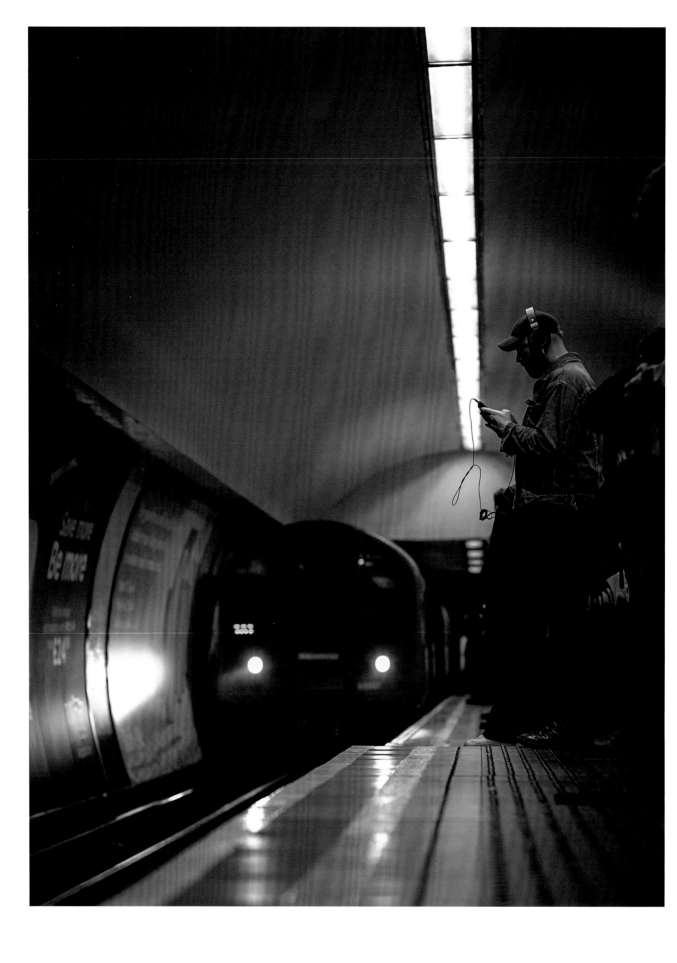

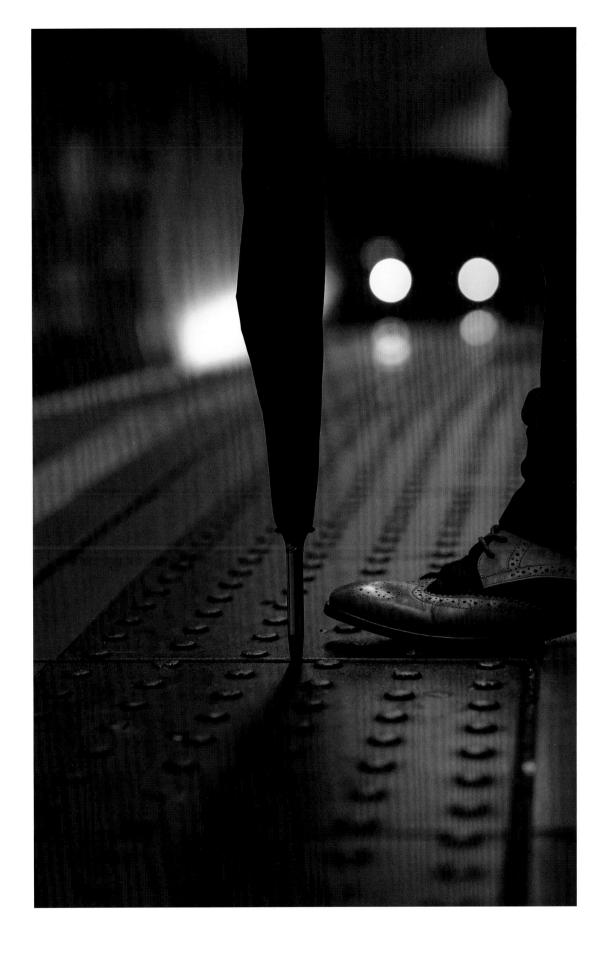

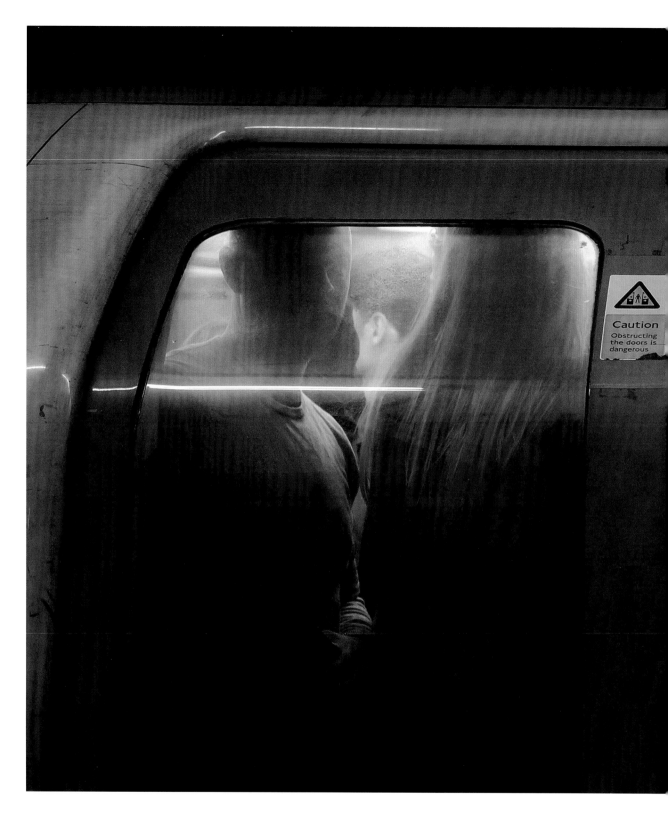

Caution
Obstructing
the doors is
dangerous

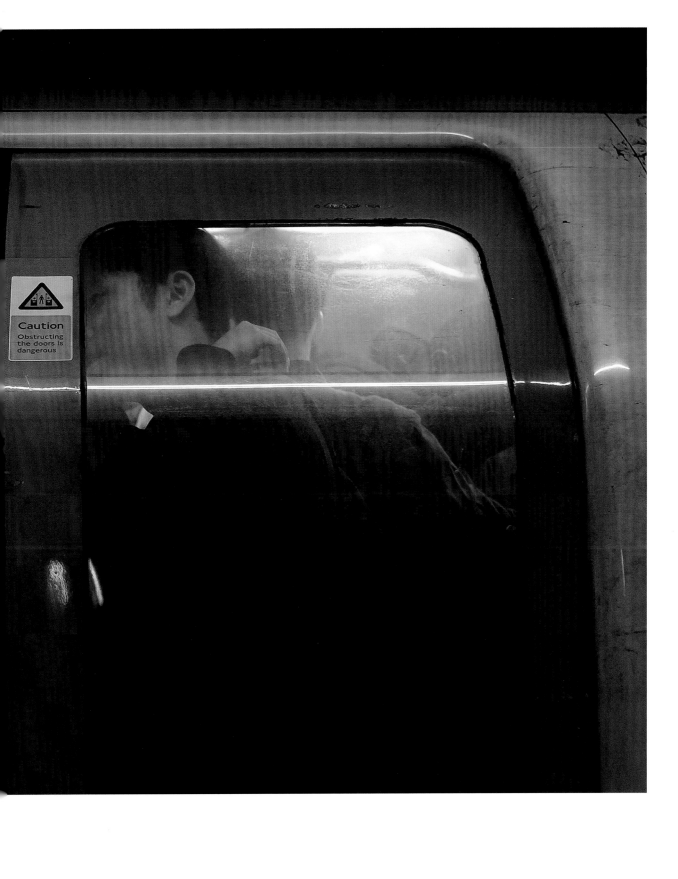

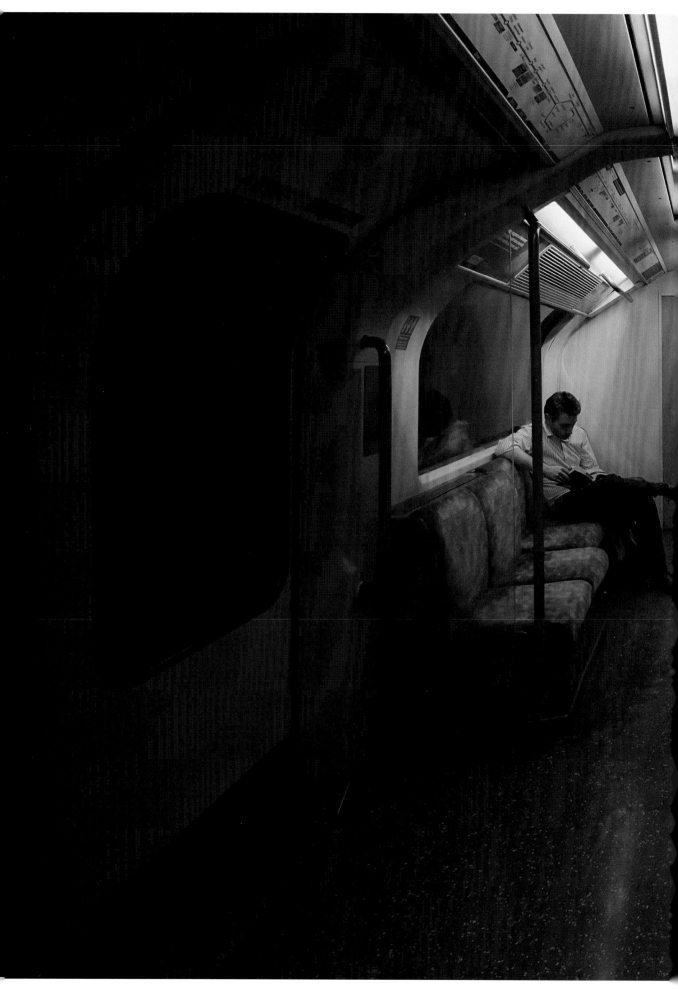

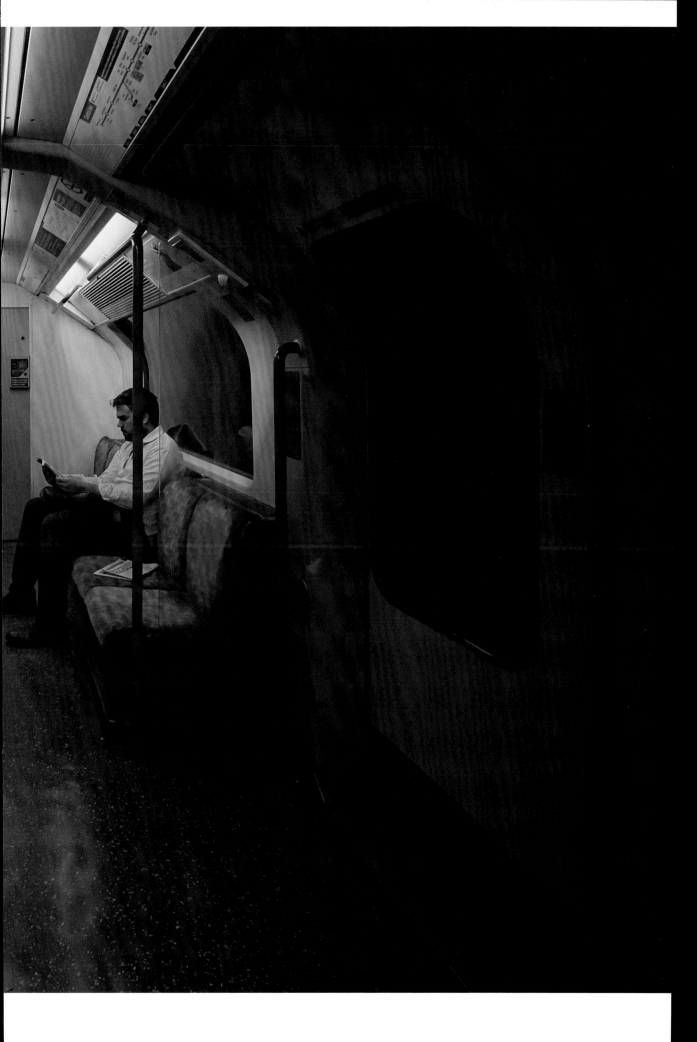

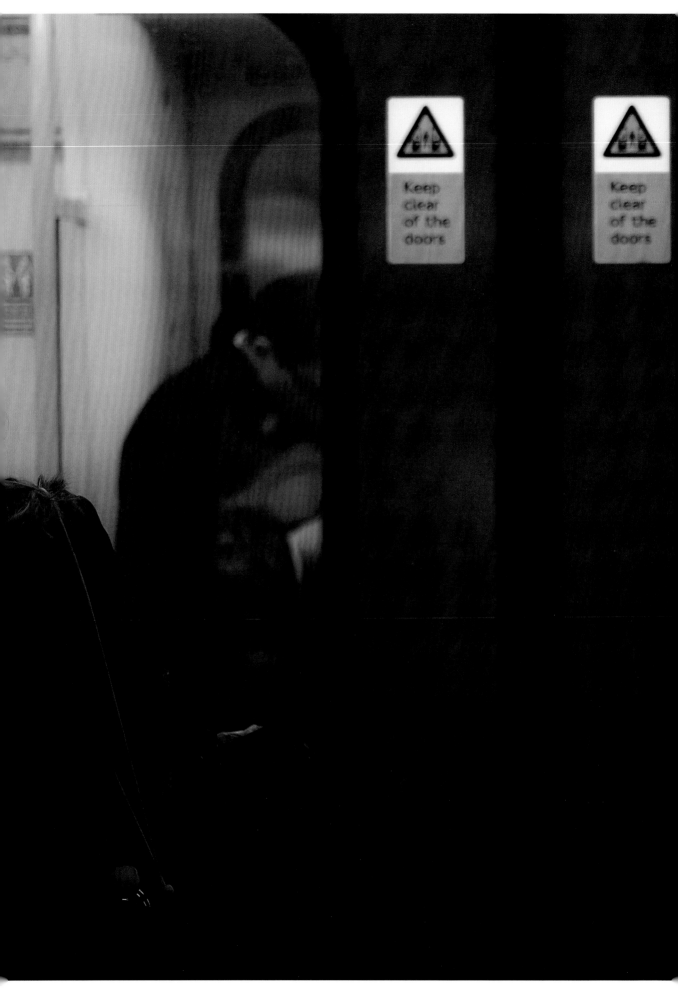

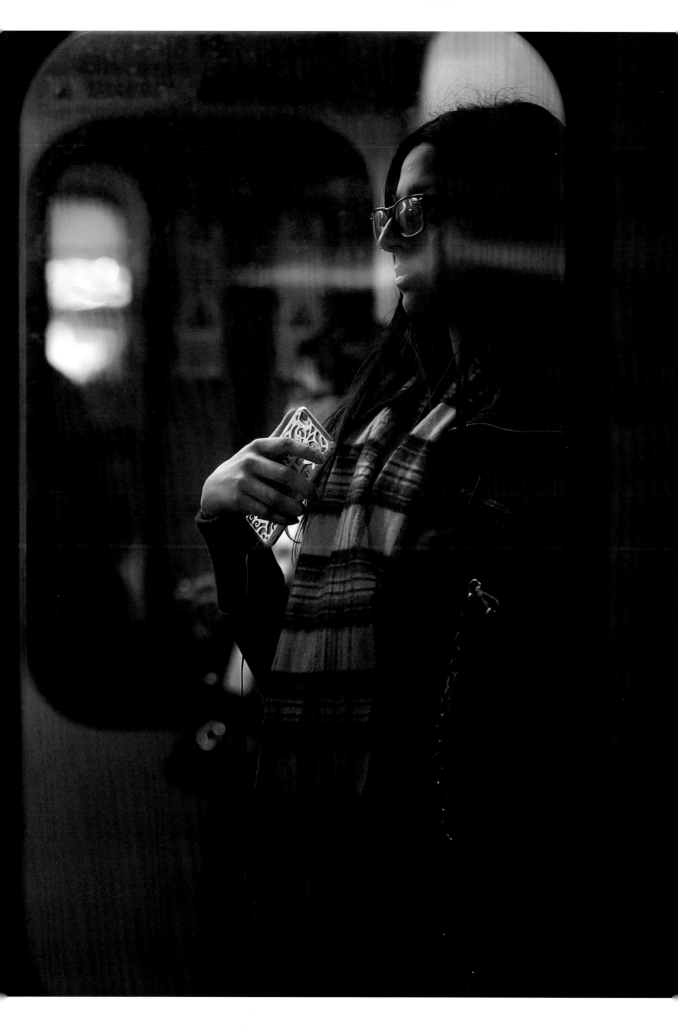

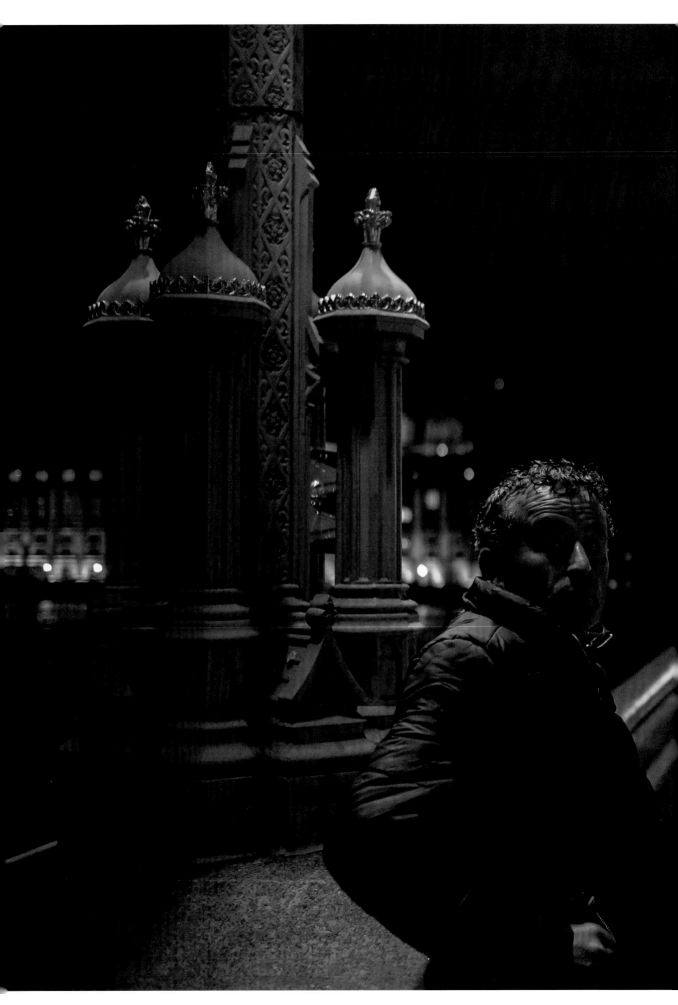

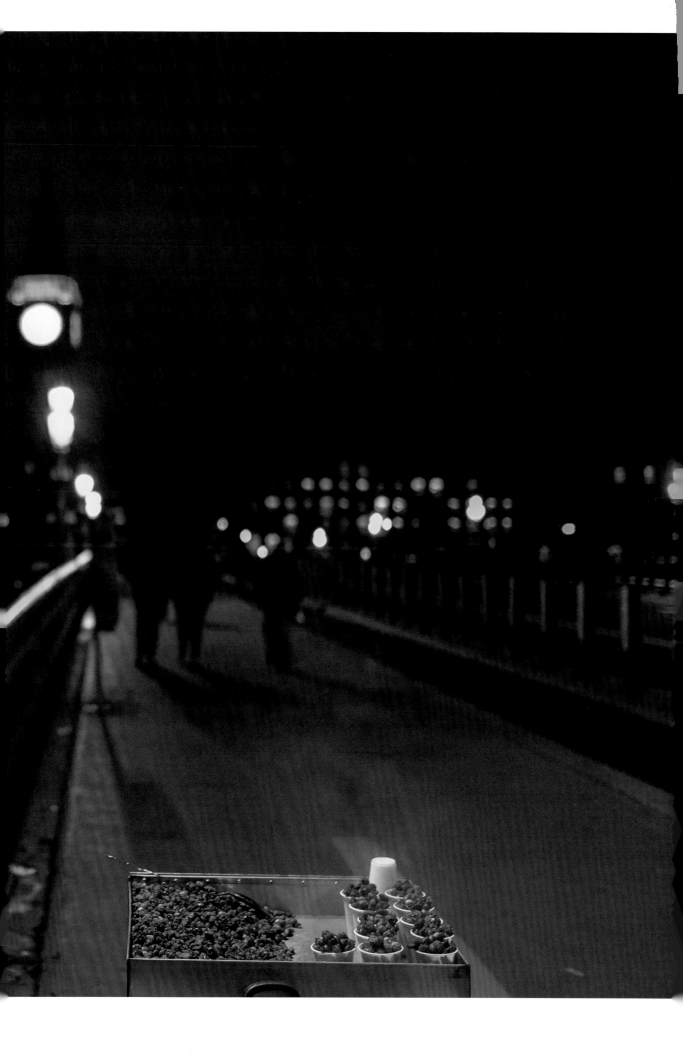

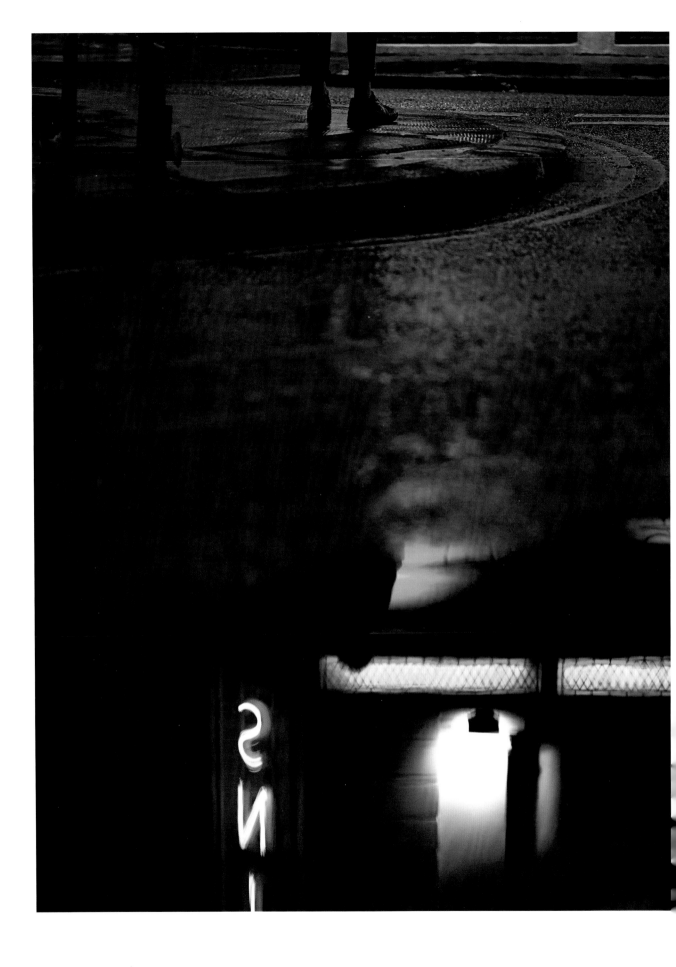

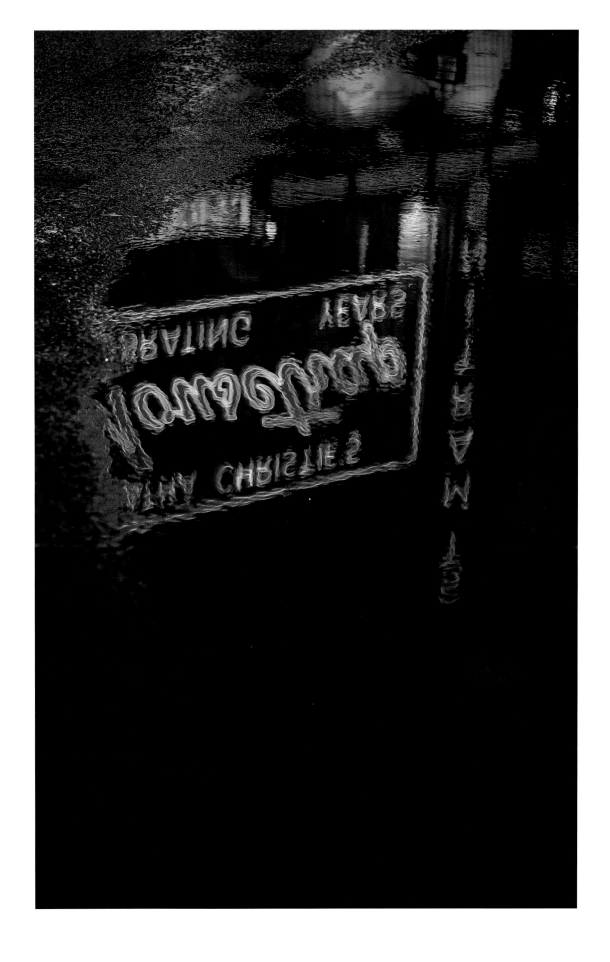

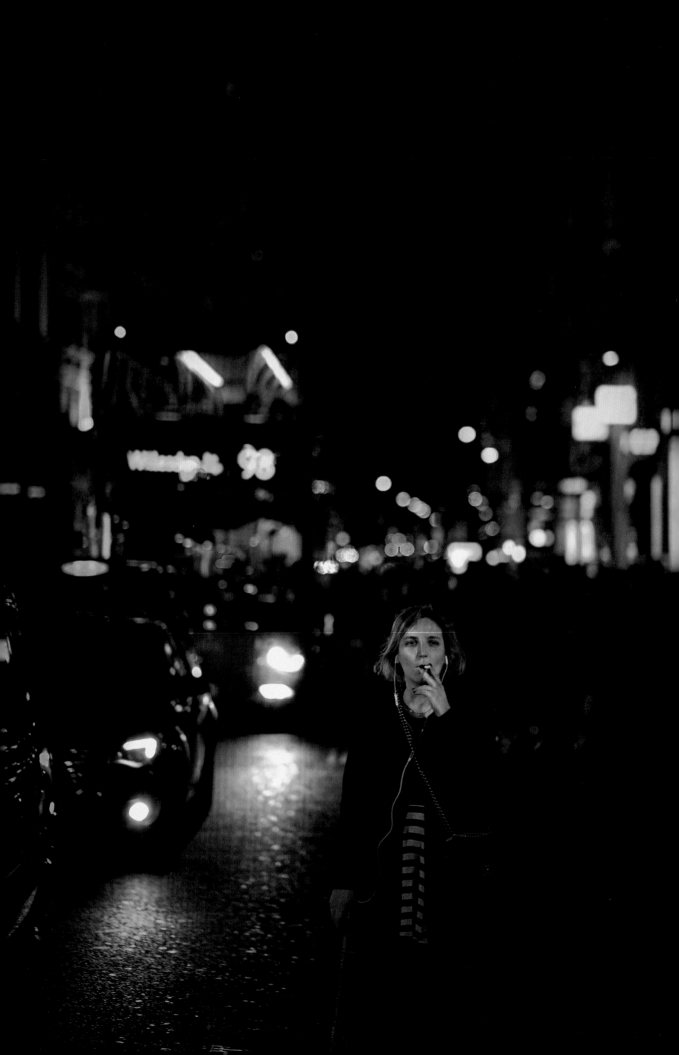

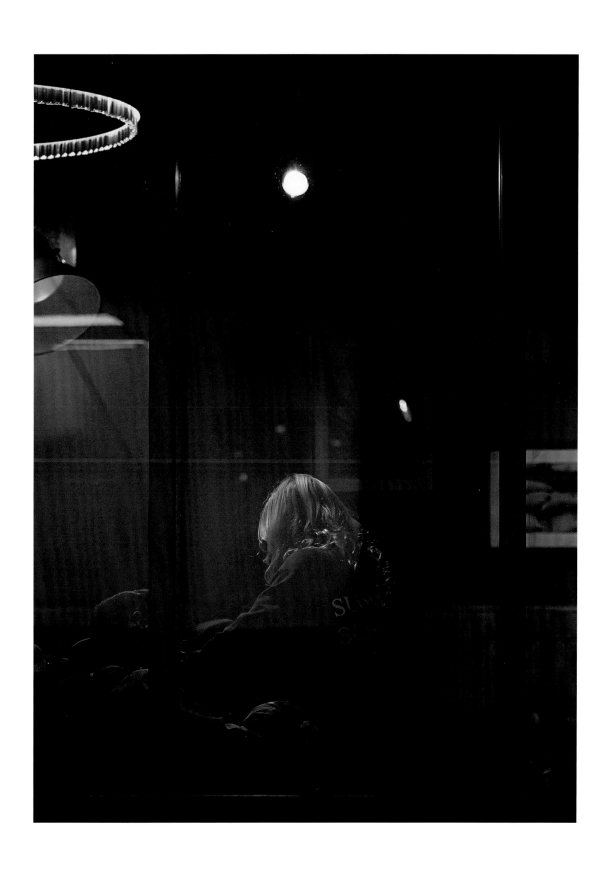

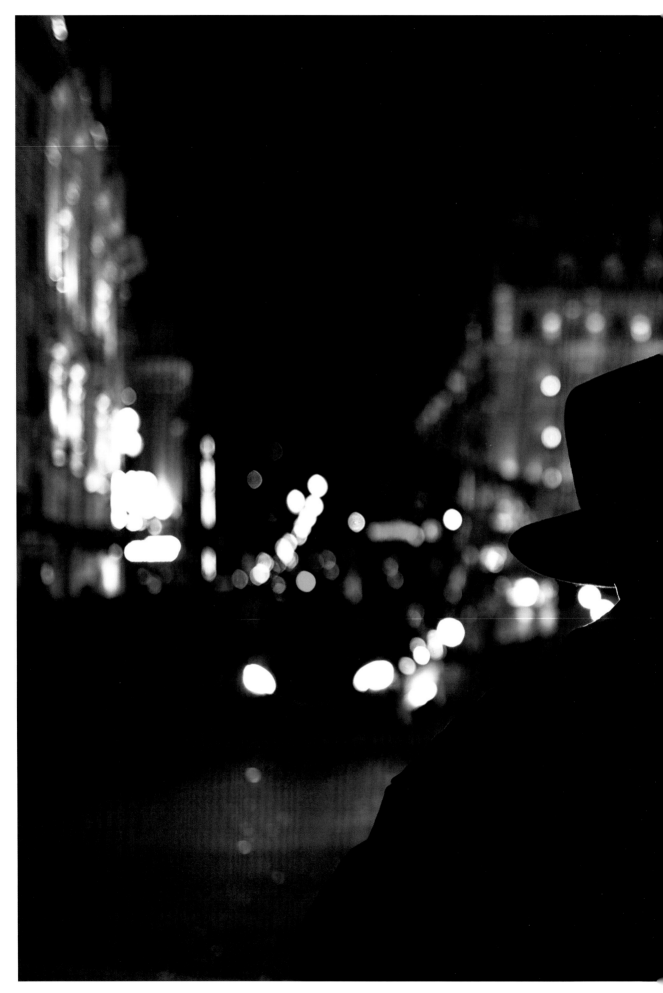

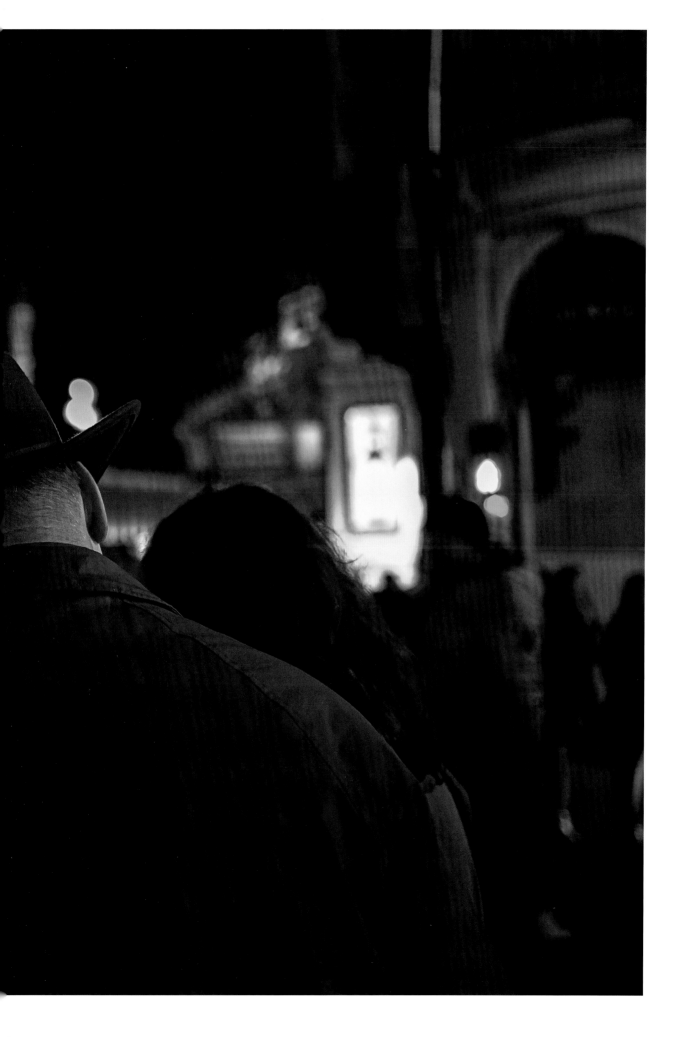

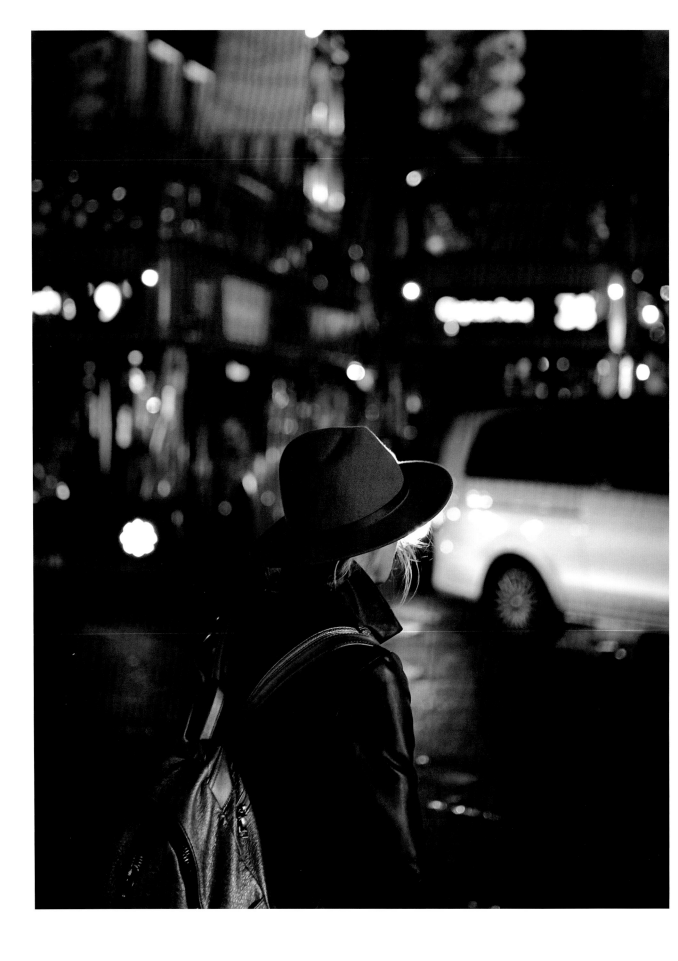

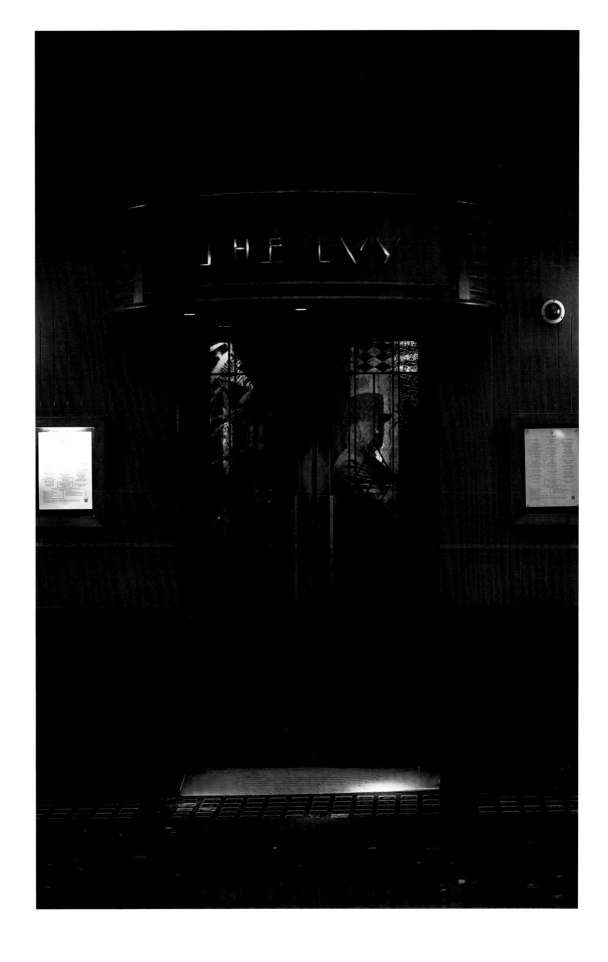

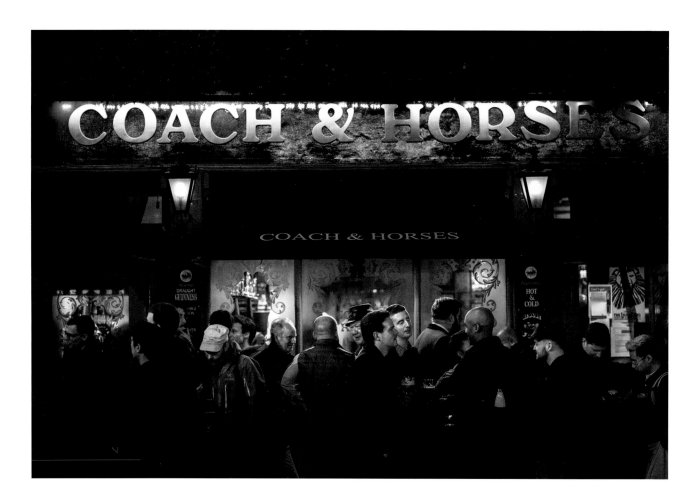

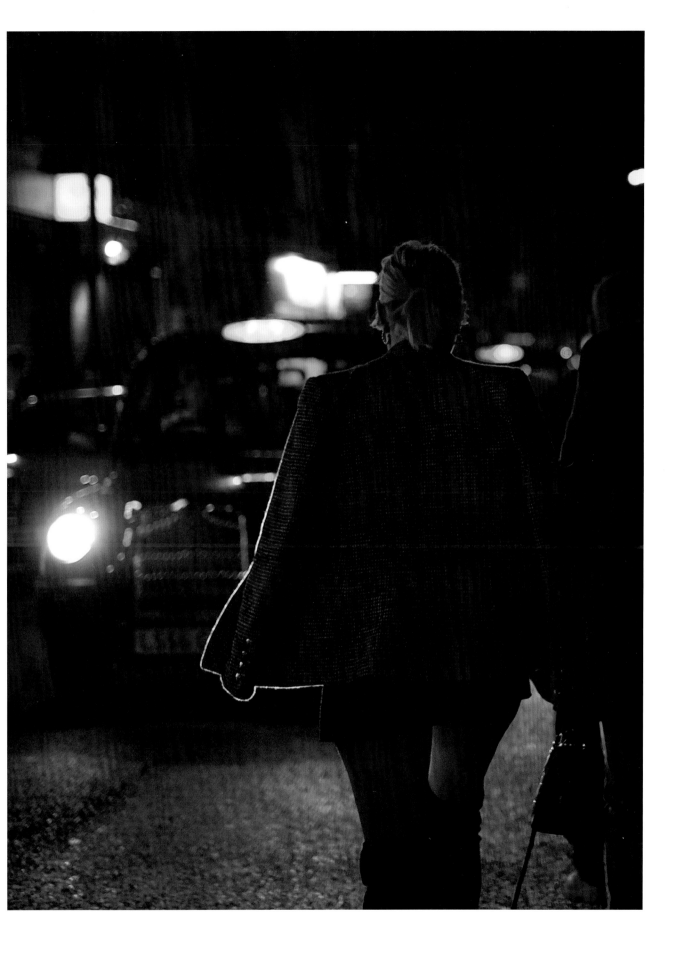

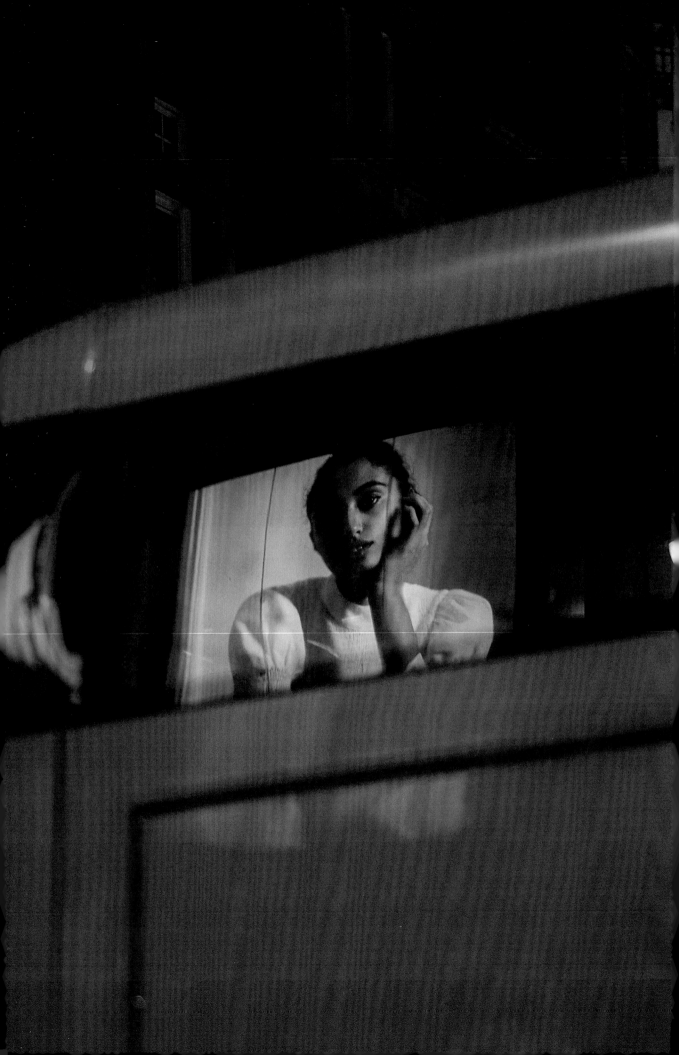

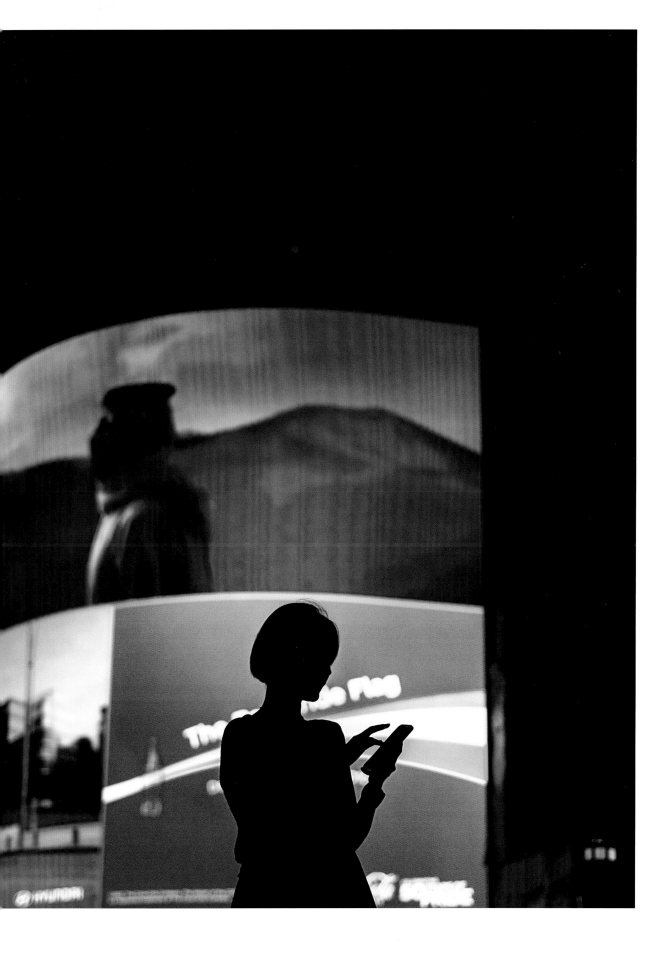

All photos were captured with
the Fujifilm X-T series and
XF prime lenses.

LCCN: 2022942421
ISBN: 978-1-9519630-1-9

Printed and bound in China
First printing, 2024

Trope Publishing Co.

The photographs from *London After
Dark* are available for purchase.
For inquiries, email the gallery
at info@trope.com

+ INFORMATION:
For additional information on
the Trope Edition Series, visit
www.trope.com